The Faces
of
Our Lives

Linda —
May God bless all
the faces of your life.
Jer. 29; 11-13

Nickie Hull

The Faces of Our Lives

of

Our Lives

A JOURNEY OF DISCOVERY FOR WOMEN

VICKIE HULL

COLLEGE PRESS PUBLISHING COMPANY • JOPLIN, MISSOURI

Cover Design by James Suiter

Library of Congress Cataloging-in-Publication Data

Hull, Vickie, 1956–
 The faces of our lives: a journey of discovery for women/
Vickie Hull.
 p. cm.
 ISBN 0-89900-810-0 (pbk.)
 1. Christian women—Religious life. I. Title.
BV4527.H85 1998
248.8'43—dc21 98-18491
 CIP

To all the very special women in my life,
especially my daughters, Emily and Lydia.
May you see yourselves as beautiful,
lovable and valuable.
And may you continue
to turn your faces toward Him.

Table of Contents

Acknowledgments

Writing this book has brought me great joy and a deeper appreciation for God and the way He cares for women. It could not have been completed if it weren't for the loving support of my husband who allowed the temporary rearrangement of our lives and freed up my business responsibilities to meet writing goals. Bert, you are my best friend and I love you.

My children, Emily, Dru and Lydia, often ate sandwiches, cleaned the house and took messages so Mom could sit for long hours at the computer. Thanks, kids, for you are my heart.

I also thank my spiritual "mother," Nancy Yacher, for her constant and positive encouragement. Thanks to Gail Todd, who helped me see the spiritual battle and instilled in me the courage to keep fighting. My gratitude also goes to Brenda Pyle, who first introduced me to the cross. Without it, nothing would make any sense.

Thanks to the women of my congregation, who provided the first sounding board for this material and prayed

for me to finish this project. A special, heartfelt thank you to Mary Beth Petr, who shared her mother's life and death with me so that others could learn.

To everyone at College Press, thanks for giving me a chance to fulfill a dream and for believing that this work can impact others. I especially appreciate John Hunter for patiently answering all my questions.

I also thank my mother, my grandmother, my great-grandmother, and all the many women who shared their stories with me. You motivated me to keep writing and inspired me by your strength.

Most of all, though, I thank God the Father for loving me as His own daughter and giving me a love for words, God the Son for forgiving me and redeeming me for a purpose, and God the Holy Spirit for being my constant guide and comforter.

Prologue

Your Face Tells a Story

Look in the mirror. Don't count your wrinkles or search for gray hair. Instead, study the face looking back at you. Who are you and where do you belong? Where have you been and where are you going? As a woman you have undoubtedly worn many faces. The face looking back at you now is not the one you had at birth. You have grown into this face through trials and triumphs, through effort and opportunity, through decisions and destiny. If you are counting wrinkles, how many of them arrived by laughter and which ones were caused by grief? The face you see now is a road map of where you've been and how life has treated you. Do your eyes sparkle or has sadness dimmed them? Is the gray hair there because of simple aging, or have you endured your share of stress and struggles? What does your face say about you right now? What do others see when they look at you?

This book isn't about physical appearance. It's about wearing the many faces God calls us to don. We will share some of these faces just because we are women. Other

faces we wear because of personal circumstance or choice. If you are young, you may not have worn many faces yet. Those more mature and experienced have possibly worn them all, and a few additional ones as well. We are all at different points in our lives; we are where God has called us to be at this time. And only God knows what faces you have ahead of you, just waiting for you to wear.

You've heard women talk about putting their face on each morning. Usually they are speaking about applying some makeup. A little of this and a little of that and those unwelcome wrinkles and age spots go into hiding. Others may mean they choose the mood they want their faces to reflect. Women can be good actresses. No matter how much pain we are in, when we walk out the front door and into the world (or into our church buildings), no one will ever guess what is really behind those empty smiles plastered across our faces. But all the makeup in the universe, and the many scripted lines we write for ourselves, can't remove the feeling of phoniness in our souls. Some of us know we are wounded, and sooner or later so will everyone else. Makeup eventually wears off and the face gets weary from holding the weight of a heavy, fake smile when the heart feels like breaking.

The chapters of this book discuss the face of a woman's soul. We are born wearing the face of a little child, both physically and spiritually. Through time and the circumstances of life that face grows and changes. It takes on new challenges. It can never return to a physical childlikeness again, for God calls us to mature and accept more of His responsibility. In addition, the world sometimes serves us a plateful of challenges, forever changing who we are and what face our soul will wear.

My prayer is that this book will be a blessing to each woman who reads it and studies God's word in conjunc-

tion with these thoughts. I also pray that when the final page is read, each woman will be able to look in the mirror and see herself as God sees her: valuable, useful, talented, accepted and loved. There is no challenge, no sin, no hurt that God can't repair and use for His glorious purposes. You are not alone. The face you wear today has been worn by others before you and will be worn by those to follow. Study who you are and prepare for what may lie ahead. Then use what you discover to help another woman along the way. No one walks by herself. We travel through life together, with God by our side encouraging us to be our best. May He bless you as you take a look at the faces of your life.

My Father's Daughter

⚜1⚜

When I was five, my parents divorced. It was a long and painful process for all involved. Adding to the hurt of his three little girls, my daddy took off. He left us without a father or an answer to his disappearance. From then on each birthday, every Christmas, and all other important events in my life occurred without him to celebrate beside me. He sent no cards or gifts; he made no calls. He never made another child support payment. And for the rest of my life so far, he has failed to reassure me that he still loves me.

Two years after her divorce was final, my mother remarried. It took awhile for me to adjust to this idea. In time I came to accept that I had a stepfather in my life, although I was uncertain what that meant exactly. One day during an extended family gathering I passed my new autograph book around among my relatives. Each one wrote some funny little poem or saying that an eight-year-old might appreciate and then signed the bottom of the page. My stepfather did likewise. I don't know if I was caught up in the atmosphere of family, or if I knew even then that I needed a father in my life, but, in any case, I took that autograph book to my room where I carefully scribbled out my stepfather's signature and replaced it with the word "Daddy."

Feeling rather proud of myself for accepting my new dad and willing to publicly acknowledge him as such, I bounded downstairs to show all the grown-ups what I had done. I had a new daddy and I wanted everyone to know how happy I was to realize this. I will never forget the look on my stepfather's face nor the tone in his voice.

"I am not your father and I never will be!" he bellowed at me in front of everyone. "And it is illegal to tamper with someone else's signature. Don't ever do it again!"

Shocked and saddened, I returned to my room where I buried my green auto-graph book beneath the clothes in my bottom dresser drawer. It was painful enough to lose my daddy, but I had also been rejected by the one I hoped would be willing to take his place. I was a little girl who desperately wanted to be loved by a father. In many ways I still am.

Look at a childhood picture of you taken with your parents. As you look at your mother, your father and yourself, how do you feel about the people in the picture? How would you describe the relationship between the adults and the child in the photo? Do the faces in the picture accurately represent that relationship?

The first face a woman wears is that of a daughter. She is a daughter before she is anything else — before being a sister, a friend, a Christian, a wife, a mother, or a grand-mother. What does it mean to be a daughter? In the beginning it probably meant wearing a lot of pink, having bows taped in your hair, getting dolls as gifts.

Many women looking at their baby pictures right now will fondly recall being "Daddy's Little Princess," being protected from nightmares in the dark, being cuddled and cared for and knowing they were greatly loved. Other women won't understand that fantasy at all. To them, being a daughter means being second class to the son their father really wanted, being ignored, living under-challenged or getting hurt by those who should have loved them most.

Unfortunately, there are women who grew up without a father. Oh, he started out in the picture. But it didn't take long for him to decide fatherhood was too much responsibility. And when he left for good, he took a part of his daughter with him that she could never reclaim — no matter how hard she tried or how many years she searched. That little girl in the picture, sitting on the lap

of her father, may have a world of pain stored in her soul. It may still hurt to look at the picture even as an adult.

The Bible tells us children are a gift of God. You were a blessing from God to your parents. It was up to them to determine what they would do with this gift and how they would treat their little present. You had very little say in the process. Gifts are to be enjoyed and treasured. They are a representation of the gift-giver's love for the gift-receiver. God likes to give good gifts out of His great love for those He created. You were a good gift. You were worth valuing. You were worth enjoying for a lifetime. That was your parents' privilege and responsibility to you and to God.

The flip side of that is you are the daughter of the parents God chose to raise you. For whatever reason, God chose your particular parents for you. Your family is no cosmic accident. Therefore, you have a responsibility to your parents whether you would have chosen to be their daughter or not. Proverbs 23:22 says, "Listen to your father, who gave you life, and do not despise your mother when she is old." This admonition is easy if you had the kind of parents who valued you as a gift from God. But what if you didn't? Doesn't that let you off the hook and give you the right to hate your parents, possibly even ignore the fact that they are your parents? No. The Bible has many verses calling children to respect their parents. Read Proverbs if you don't believe me. God is serious about us keeping our end of the family bargain out of obedience to Him.

Ephesians 6:1-3 tells us, "Children, obey your parents in the Lord, for this is right. 'Honor your father and mother' — which is the first commandment with a promise — 'that it may go well with you and that you may enjoy long life on the earth.'" We daughters have

been called to obey, not just as children living under our parents' roof, but even as adult children of our parents. Obedience is right because it teaches us to obey Christ. People who have not learned the lesson of obedience as children have a hard time fully obeying the Bible later on as adults. They have a problem accepting and trusting God's authority, making the Christian life a constant struggle of the will. We have all seen unruly children and it is not a pretty sight. Unruly adults are just as ugly.

Not only are we called to obey our parents, but God also asks us to honor them. The reward will be long life that goes well. Honoring means to hold in high esteem. It is simply not enough to send a Hallmark card whenever Mother's Day or Father's Day rolls around. That is obligation, not honor. Honoring requires staying involved in your parents' lives, putting their needs high on your priority list and treating them respectfully.

This is easy if you think your parents are people worthy of honor and respect. But what if your parents were abusive or drank too much or even abandoned you? Surely God doesn't expect you to treat such people with honor. They don't deserve it, right? Wrong. There is no qualifier on honoring your parents. The Bible instructs to honor your father and mother. It doesn't say honor your father only if he stuck by you through thick and thin. It doesn't say honor your mother only if she stayed sober and never hit you. Your parents might not have done a very good job, and their bad behavior is not to be condoned, but they are still the gift-receivers of you. If you choose to dishonor your parents, those feelings of resentment and hate will eat away at your soul and you will endanger yourself spiritually and emotionally, possibly even physically. But if you honor your parents and try to understand them (along with their pain and set of life's

circumstances), your soul will benefit. And, according to God, your life will go well.

In the Bible we see examples of children who honored their parents even under very stressful circumstances. For instance, Jonathan didn't rebel against his father, King Saul, even when his dad tried to murder Jonathan's best friend, David. King Saul was so tormented by jealousy, he hurled a spear at his own son in an attempt to kill him. Jonathan confronted his father about his evil behavior, but to no avail. When things continued to escalate, David ran from Saul and went into hiding. Jonathan warned David about the impending danger, but did not leave his father's household to go with his friend. It couldn't have been comfortable living in the home of a spiritually tormented father, but Jonathan stayed. And in the end Jonathan died defending his father's honor in battle.

In-laws are also parents and they, too, deserve honor. We live in a society with many in-law jokes. But remember, your mother-in-law and father-in-law raised the man you chose to marry and love for a lifetime. Your husband was given to these two people as a gift from God. These are the people who held and rocked the man you love when he was a baby. He was molded and shaped by them. He wouldn't be who he is today without their influence. They had a hand in raising the man you find so attractive. For that they deserve honor, not contempt.

There is a poem that speaks directly to the heart of in-law relationships. I cross-stitched it and gave it to my mother-in-law. Whenever I visit her house, I look at that framed piece. Each time, I am reminded of the woman who nurtured her little boy into the man with whom I share my life, my home and my children. It encourages me to love, honor and respect this woman for the gift she has given to me. Imagine the impact the following words

would have on your relationship with your mother-in-law.

To His Mother

"Mother-in-law" they say, and yet,
Somehow I simply can't forget
'Twas you who watched his baby ways,
Who taught him his first hymn of praise;
Who smiled on him with living pride
When he first toddled by your side.
"Mother-in-law," but oh, 'twas you
Who taught him to be kind and true;
When he was tired, almost asleep,
'Twas to your arms he used to creep;
And when he bruised his tiny knee,
'Twas you who kissed it tenderly.
"Mother-in-law" they say, and yet,
Somehow I never shall forget
How very much I owe
To you, who taught him how to grow.
You trained your son to look above,
You made of him the man I love;
And so I think of that today,
Ah, then with thankful heart I'll say,
"Our Mother."

(author unknown)

Stepparents are a tougher subject. Childhood was filled with stories about wicked stepmothers in tales like Cinderella and Snow White. It can be very hard for a child to grow up with a stepparent when she would rather have her real mother or father back. Few children like the thought of a stepparent. Nevertheless, stepparents accept the role of child raising and nurturing when they marry that child's mom or dad. For this reason children need to honor the stepparent and not purposely cause strife in the

household. Sometimes this can only be done through much prayer.

I was in my mid-twenties when I learned my mother would marry for the third time. I really did not know how to feel about having a third father figure in my life. I had already been disappointed by a father and a stepfather. Why would another man be any different? I tried to tell myself this man would be nothing more than my mother's husband to me. At the time, I rationalized that I was an adult woman, busy raising her own family, and had no use for a father any more. I have since come to understand that a woman never outgrows the need for a daddy.

I do not call my mother's husband "Dad," and it still catches me off guard to hear my children refer to him as "Grandpa." Unconsciously, I have protected my heart against more disappointment by withholding my affections from him. Psychologists would call my rationale understandable, I'm sure. But it is unfair for me to judge all men by the actions of the two who dominated my early years. In many ways, my mother's husband has treated me much like a daughter. He is kind and generous to my children and regularly stays in touch with my husband and me. There is nothing he would not do for my mother or the rest of my family. Realizing this helps me separate him from the others.

With God's help, I am realizing that all parental figures — biological, in-law, adoptive or step — deserve their own chance. They shouldn't have to live in the dark, shameful shadows of anyone previously holding the position. Continue to ask God to help you overcome hurt induced by a parent. Ask Him to bless you in your current relationships. Judge each person on his own merits, not by the actions of others. Learn to forgive. The relationship you reap will be worth the effort.

We are called to honor God first, before our parents. That is the meaning behind "in the Lord," in the Ephesians passage mentioned earlier. In 2 Chronicles we read about Manasseh, a horrible king, the worst there ever was. "He did much evil in the eyes of the LORD, provoking him to anger," the Bible reads (33:6). Manasseh erected false idols, murdered many people and hideously sacrificed his own son in the fire of idol worship. Even though he later repented, he had already taught another son, Amon, to do evil. Amon likewise became an evil king. Amon knew his father had repented, but he still chose to do wrong. Ironically, Amon's son, Josiah, who had also seen a childhood of horrors, chose to do right as king. He tore down all the idols and turned the people back to God. This story illustrates that parents aren't entirely to blame for their children's actions, particularly their grown children. We choose to do good or evil. While it may be easier to honor our parents if they are "in the Lord," we can't use their ungodliness as an excuse for our own sins. The choice is ours to be "in the Lord" or not. Your parents can guide you, even influence you, but they can't choose for you.

Another necessary element in honoring our parents is forgiveness. The Bible is filled with passages on forgiveness. These passages apply to our parents, as well as to others. Sometimes we forget parents too have a past and were once someone's little boy or girl. The people who raised us may also have souls filled with pain. They are imperfect humans. Your mom and dad were nonexperts when it came to knowing how to accept a good and valuable gift from God. Maybe they didn't feel worthy of the gift of you. Maybe they still don't. They need forgiveness for this inadequacy.

Take some time to get to know your parents, who they are and where they've been. What were their hopes and

dreams? What has gone into making them the people they are today? What pain and disappointment have they endured? You don't have to accept their sins. Pray for them to get rid of anything holding them back from God. Look at your parents as real people, sinners in need of God's mercy and grace, just like you would anyone else, including yourself. It will help you forgive your parents for hurting you. And it will increase your chances of finding ways to honor them. It's a situation where everyone wins.

Maybe you are reading this right now and feeling a different kind of pain. You have no parents to honor and forgive. That hurts, especially when the world is celebrating a family holiday. Mother's Day and Father's Day can be pretty rough on women who long for parents but don't have them. Their parents may have died or divorced or committed suicide or abandoned them.

When Pam was very young, her mother died from breast cancer. Her father was physically and sexually abusive and finally abandoned his children. Pam explained her feelings to me as she thought of her adult friends and their ongoing relationships with their moms and dads:

"I wish I had a mother who would touch my hair and say, 'I like your hair like this,' or, 'Have you thought of getting your hair cut?' I wish I had a mother who would take an interest in my children. I wish I had a dad who would tell me he loves me, who calls me his little girl and tells me I'm pretty — a dad who would hug me without any hidden motive."

Pam's words are heartbreaking. Even at age 40, she has a great need to be loved, valued and accepted by her parents. She didn't deserve what happened to her. She would give anything if she could have back the opportunity to honor her parents. Most of all, she longs for love with skin on it — human love — so she could feel, see,

touch, and hear her parents' approval of her as their precious daughter. Healthy parents provide their children with love, approval, affirmation, self-worth and value. But those who have no parents, or very dysfunctional ones, miss out on these ideals.

If this fits your situation, you have several options. First, try to mend your broken parent/child relationships if possible. It still hurts that my father abandoned me at a young age. Even as an adult I long to know that he loves me and cares what happens to me. To get this blessing I have gone to great lengths to find him and ask to have our relationship mended. I have searched on my own for several years and eventually reconnected with his family members. While I have found an uncle and a grandmother, I am still without my father. I may have to settle for that. I know I have done everything humanly possible to mend this vital relationship.

I also know that I have done everything supernaturally possible. I have spent much time in prayer on the matter and have asked others to petition God on my behalf. If we never reunite, I know it is by my father's choice and not because I didn't try or because there is something inherently wrong with me. And even though I put the matter in God's hands, God allows everyone free choice. It is not God's fault if my father continues to reject me. Just like He doesn't force me to do anything, He won't force my father into a relationship with me either. It is always God's will for a child to be loved and valued by her parents. God is not to blame for my earthly father's absence. I simply need to remember that sometimes God answers prayers with a "yes" and others with an "I'm sorry, but no."

If attempts to reconnect with your parents fail, you have the option of "adopting" other people. Throughout the years, I have sought father figures. My father-in-law

was first. On my wedding day, he gave me the nicest gift. It wasn't wrapped up in shiny paper like all the others, but came straight from his heart. As soon as the wedding was over, my new father-in-law made his way down the aisle toward me. When he reached the foyer, he wrapped his arms around me in a tight embrace and said, "Welcome to my family." From that moment on, I called him Dad.

Don, an older man I once worked with, provided great fatherly wisdom when my daughter left for college. He acted in every way how a father would when I intensely missed my daughter. He listened, he was patient, he let me cry, and when I got quiet, he gave me counsel of hope and courage. When Don died, I felt as if I had lost my father all over again. But the pain was worth knowing this man. Each year I send Father's Day cards to older men who have treated me as they would a daughter. They don't think it is strange; they are honored.

The greatest gift you can give yourself is the ability to see God as your Father. You are your heavenly Father's daughter. Psalm 27:10 says, "Though my father and mother forsake me, the LORD will receive me." And Psalm 68:5 reads, "A father to the fatherless, a defender of widows, is God in his holy dwelling." God cares about you and wants to be your Father. Unlike human parents God will never leave you and He will never hurt you. That's a promise!

Back to Pam, my parentless friend: "When I need a mom or a dad, I ask God if He will hold me. I imagine Him letting me sit on His lap and holding me. It's amazing how I feel His love at those times." Pam has discovered a spiritually healthy way to let God fill the void in her life. He's not love with skin on, but His love is perfect and never-ending and has the ability to fill her soul in ways no human ever could. We all need to be valued and

loved by a parent no matter how old we get. Even if our human parents can't or won't provide that for us, our God does.

If we were to go back and look at those pictures of us with our parents again, we might see things a little differently now that we have compared our imperfect, human parents with the perfect love of Almighty God. Most human parents do the best they can with what they have to work with, but that can never compare with what God is capable of giving us. Only He can fill the looming void we have in our lives — the need to be loved unconditionally for all time. We need to stop expecting our earthly parents to be what they can't be now or couldn't be back then.

This point finally became clear one summer while serving as a senior counselor at a children's church camp. During daily quiet devotional times that week, I felt God simply telling me that He loves me. I found this simplistic because I thought I already knew that. And I probably did, at least intellectually. But I hadn't made the connection in my heart about being God's child and Him being my Father/Daddy. On the last night of camp the children sang spiritual songs around the campfire while the stars twinkled overhead in the crystal clear sky. Suddenly, they began singing a song I had never heard.

> *I love you Lord, and I lift my hands,*
> *To worship you, oh, my soul demands.*
> *Take joy my king in what you see;*
> *May I be a sweet, sweet child on your knee.*

I looked around at all those beautiful, little children raising their arms in praise to God, beseeching his approval and love, and my heart broke. As tears poured down my cheeks, it became real to me why God had been reminding me of the simple message of His love. "You see

these little children? That is how I see you," God seemed to say to my heart that night.

We adults think we are so grown up that sometimes we almost feel a peer to God. That is a false perception. God taught me that lesson at summer camp. To Him even adults are children. God knew I longed to be someone's little girl, to have a father who loved me with all his heart. That night, I learned I am God's child — His little girl. He is my Daddy. And He will never leave me.

Reflecting on My Face as a Daughter

Ephesians 1:4-5 —

When did God first love you?

How do you feel about being adopted by God through Jesus?

What kind of life does God want you to have as His adopted child?

John 1:12-13 —

Relationships, even parent/child ones, are a two-way street. What is your responsibility as God's child? What can you give back to Him?

What are practical ways you can honor your earthly parents?

Romans 8:14-17 —

Abba means "Daddy." God is your Father and also your Daddy. What is the difference? What does a daddy do differently than a father?

What is the Holy Spirit's part in our parent/child relationship with God?

How do you feel about being a coheir with Christ and an heir of God?

What is the inheritance?

What must we be willing to do in order to be a coheir? Are you willing?

Mark 5:32-34 —

This is the only time in the New Testament that Jesus calls a woman, "Daughter." Why do you think he did so for this particular woman?

How do you think she felt being called "Daughter" by Jesus? (Remember the years of great suffering and her ostracism from society at large.)

2 Corinthians 6:18 —

What does this promise mean to you? How will it change your life knowing this?

Hebrews 13:5b —

Do you trust God when He says he will never leave you? Are you willing to let Him be your Father/Daddy for all time?

Someone to Call Friend

⇒‡2‡⇐

The last time I saw my brother-in-law, Mike, he was lying unconscious in the neurology intensive care unit of a large teaching hospital. I had to look closely to make sure it was really him. Being a newcomer to any intensive care unit, I was dazed by the many tubes and wires running in and out of nearly all of Mike's bodily orifices. High-tech bedside machines that kept a constant vigil and recorded Mike's vital signs and the condition of his brain emitted rhythmic blips and bleeps. It seemed inconceivable that this energetic man — a long distance runner, art professor, husband and father of three — could have fallen from a ladder, cracked his skull on a pile of rocks, and wound up in this unknown planet called intensive care. As I looked down at him, the only reminders Mike gave that he was still alive were his machine-made audible heartbeats and the sporadic coughing his body tried to produce around the ventilator snaked down his windpipe.

Somewhere around three a.m., the coughing stopped. And even though one machine still recorded heartbeats and another forced air into his lungs, we began to realize that Mike's spirit was no longer with us. Several hours later when the doctors came to make their rounds, they confirmed what we didn't want to hear but already knew in our hearts to be true: Mike's life on earth was complete. His young widow, my husband's sister, collapsed in the arms of her sister and wept loudly. Then she courageously set about the torturous task of telling her children their daddy would no longer read them stories or toss any more baseballs their way. The scene was one of the most gut-wrenching I have ever witnessed, changing my life forever. Yet in a way I never expected, I felt honored to be a part of this terrible pic-

ture. As I would come to learn later, it's times like these when we see what we are capable of being for another. It's during these moments we learn the bond of friendship and the meaning of sacrificial love.

In the hours and days that followed Mike's passing, his friends sprang into action. They rallied around my sister-in-law, bringing mountains of food, cleaning her house, serving at the funeral reception, providing hours and hours of child care, writing letters of encouragement, housing out-of-town relatives, shuttling people back and forth to the airport, and grocery shopping. You name it, these friends did it. I have never before nor since seen such a display of loving friendship.

This generous outpouring posed a real dilemma for me, though. What kind of friend have I been all these years? Would I think to perform these acts of support and kindness for my friends if they were in this same sad situation? Would anyone do these things for me? Would I be alone or surrounded by supportive friends if my husband or a child died? I pondered these questions and many similar ones as I watched true friends pulling together for the sake of someone else. It was a powerful lesson in an age when we think most people are too busy to get involved. It was a lesson I badly needed.

If you were to write a classified advertisement for a friend, what would it say? What do you want and need in a friend? It is rather pathetic to think about having to advertise for friends and I am not recommending you do so. But just for fun, take a piece of paper and try writing an ad for the kind of friend you most desire. Good friends are a gift. And a best friend is a great treasure. Friendship is a two-way street. It provides an avenue for mutual rejoicing and shared sorrows. Lasting, successful friendships require honesty, integrity, sacrifice, humility and vulnerability. Friends share interests. They don't mind crying in the theater seat beside you during *Titanic*. They will shop till they drop or walk with you each morning for exercise. But the very best friends are friends of the soul. They are the precious few you can expose your true self to, who will cheer you on toward your goals and cry with you during your greatest hour of need.

There are many examples of true friendship in the Bible. Jonathan and David were so close they were said to have souls "knit together." Jesus was so connected to Mary and Martha that He compassionately wept right along with the sisters when their brother died, even though He knew He would raise Lazarus from the dead. The apostle Paul considered the physician, Luke, to be among his "dear" friends. When others felt the heat of the missionary battle and deserted Paul, Luke never faltered but stayed steadfastly by his friend's side.

Then there were the three friends of Job. Spiritual warfare between God and Satan caused Job to lose his servants, animals, children and even his health. Any one of these losses would be enough to crumple most people. Even though they didn't do or say all the right things, three good friends came to Job's aid during this crisis. Job 2:11-13 says that when Eliphaz, Bildad, and Zophar heard of Job's plight, they set out from their homes, met together and formulated a plan for comforting and sympathizing with their friend. This required sacrifice. Think how hard it would have been in those days to communicate with each other and plan a long trip. It would be no quick weekend airplane dash across the country, overnight bag in hand, like we can manage today. These men had to arrange transportation by foot or animal, secure people to run their businesses and do their chores, and situate their families to function in their absence. Also, since Eli, Zo and Bil were all from different tribes, they somehow had to send messages back and forth to formulate a plan for helping Job. And that was before AT&T.

What strikes me most, though, is their desire to "sympathize and comfort." Sympathizing means actually feeling another person's pain. When someone dies in our culture, we buy a sympathy card, mail it off and believe we

have done our part. This requires very little thought or effort. Think how much more meaningful it would be if the sender personally wrote a sympathetic message instead of relying on the greeting card industry. If we are too busy to express concern for a friend, then we are too busy.

Comfort is a close cousin to sympathy. Comfort is defined as consolation in time of trouble or worry; it means to give cheer, strength and hope; comfort means easing grief or trouble. With all his children and servants dead, his animals stolen and his body covered with painful boils, Job certainly needed strength, hope and cheer. His friends set out to give that to him. Imagine the conversation they had along their designated route.

"Poor Job," Bil probably said. "One of us needs to schedule an appointment with his doctor to get something for those awful, painful sores."

"Yes," Zo would have agreed, "and he is going to be really hurting from losing his kids like that. Maybe we should remind him of all the wonderful times they shared."

Eli undoubtedly chipped in, "How is he going to make a living now that his animals are gone? Maybe we should have each brought along a few spare goats or sheep." And on and on for the duration of their trip.

No matter how much this trio discussed Job's predicament, they were not fully prepared for the sight that met their eyes. The Bible says when Bil, Zo and Eli saw Job from a distance, he looked so grotesque they hardly recognized him. They began to weep aloud, tearing their robes and sprinkling dust on their heads — all signs of intense mourning. These men felt genuine empathy for their friend. Empathy is a little different than sympathy. While sympathy means to feel another's pain, empathy is an intellectual identification with another person. I would

bet when Bil, Zo and Eli saw Job so disfigured by his physical affliction, they couldn't help but wonder how horrible it would be if they were in Job's sandals. And so they mourned.

For seven days and seven nights, Job, Bil, Zo and Eli sat on the ground together. No one said a word. The three friends didn't speak to Job because "they saw how great his suffering was." That touches me. Friends who just sit with you and keep their opinions to themselves are rare. Most people want to avoid any kind of terrible situation if they can. "So sorry to hear about your troubles, Job. I'll pray for you. I'll get my church to pray for you. Let me know how things are going. Hope it all works out okay." Sad to say, many people would have responded to Job like that. Bil, Zo, and Eli came in person. They sat mourning and speechless with their friend for an entire week.

If we can muster the courage to get involved, we usually want to barge in and fix the situation. We can't stand to see others struggle, so we encourage them to hurry up and be healed. "You'll get over it in time, Job. Before you know it, you'll feel better again. You and your wife can have other children. In no time at all you will have animals and servants again. You're not helping yourself by just sitting here on the ground. It's time to get on with life." Sound familiar? We have all heard well-meaning folk utter unhelpful, shame-packed phrases like these. Maybe we have even said them ourselves.

It is amazing that Bil, Zo and Eli didn't speak during that entire week. They merely suffered alongside their friend, paying close attention to his afflictions. They waited for him to speak first. They sacrificed time to sit there seven long days and seven long nights. It wasn't easy or comfortable for them to do so. They felt Job's pain inside

their own souls. They identified with his suffering and they mourned his losses.

We can learn a lesson from these friends. Forget about trying to say exactly the right thing in a terrible situation. Sometimes there isn't anything to say, and being a physical presence is better than all the greeting card words in the world. Simply be there for your friend. Sympathize if you have experienced similar struggles or empathize if you haven't. With help from others plan ways to aid your friend. The one experiencing the tragedy can't always think clearly. Her sadness clouds her mind. That is where friends can pick up the slack. However, first they must spend time mourning the loss with their friend.

If you continue reading Job, you will see that Zo, Bil and Eli weren't always helpful. Some of their advice was downright dumb. In fact, they eventually resorted to blaming poor Job for his plight. It damages any friendship to blame a suffering person for things totally out of her control. If a friend is sick, don't ask her what she did to offend God. If her child leaves the church, don't ask if she set a proper biblical example in the home. If her husband cheats on her, don't imply that maybe she didn't meet all his sexual needs. If she loses her job, don't reason that God might be punishing her for something. These comments won't help. She is already feeling badly. Such remarks will cause her to withdraw further and doubt herself and her faith even more. Friends don't compound problems for their friends.

Job's friends, like us modern-day imperfect humans, didn't always say the right things, but at least they came to Job's aid. They didn't send a sympathy scroll and go on about their business, hoping someone else would do the mourning deed in their place. They came, they sat, they cried — their presence was a blessing.

Now let's look at Job's wife. Her response to her ailing husband was, "Are you still holding on to your integrity? Curse God and die" (Job 2:9). I have heard Job's wife condemned for this response time and time again in women's Bible study groups. However, it is important to remember she also lost her children, her servants, her livelihood, her animals, and on top of that, her husband was sick with hideous boils! Mrs. Job lost as much as her husband did and she, too, was suffering. Although not very faithful, her response to Job was understandable.

But where were her friends? There is no record of a single woman visiting Mrs. Job in her time of mourning. No one came from a distance to sit with her. No neighbor dropped by with a casserole or an offer to help. No one told her God was still there for her. No one offered to pray with her. She was helplessly alone in a tremendous time of need. Imagine if your children were killed, your home was destroyed and your husband was so sick he couldn't work and none of your friends came to help or offer comfort. You would be devastated! Maybe if Mrs. Job's friends had come and attended to her the way Bil, Zo and Eli did for Job, her attitude would have been better. Maybe her faith would have been stronger. Maybe if she hadn't been so alone in such a terrible time, we would have record of her in a more positive way. But no one came and Mrs. Job got scared and resentful. I am convinced friends could have made a world of difference in her case.

So how do we define this thing we call friendship? How can we recognize a true friend in our lives? Let's put it in practical terms. When a friend announces her plans to go on yet another diet, don't remind her that the last five failed. If your friend's husband forgets their anniversary,

don't impress her with the latest piece of jewelry your husband bought for you. When your friend tells you she is pregnant for the third time, don't respond with, "Again?!?" If she loses that baby, don't tell her she can have others.

If your friend's family can't afford a vacation this year, don't offer to bring her souvenirs from yours. When your friend's grandmother dies, don't tell her, "She was old and lived a rich, full life." If your friend complains about her husband, don't take sides or offer any advice other than for her to work things out with him. If you tell a friend you will call her later, do it; make her a priority.

Don't tell your friend, "I told you so," or "You'll get over it," or "Oh, well, it wasn't important anyway." A friend never says, "I know just how you feel." But she does know how to say, "I'm sorry." If your friend has a new opportunity peeking over the horizon, don't drown her with all the things that could go wrong. If her child makes a bad choice, realize that anyone's child can make a mistake, even yours. Cry with your friend. Laugh together. Be genuinely happy for her. Be honest, but not mean. Be concerned, but not nosy. Be real, not superficial. In general, just be there for your friends, even if it means simply sitting in silent support.

For fun I decided to write my own classified advertisement for a friend. Maybe it will give you some ideas of how to be a true friend and how to foster quality friendships.

Wanted: Friend. Someone who likes me for who I am and doesn't consider me a project to be remade and reshaped into someone better, but still has a vision for me to grow. Someone who isn't jealous of my accomplishments, but is my biggest fan, urging me to use all the gifts and abilities God has given me. Someone who asks about my spiritual life and is interested in what God is teaching

me at the moment. Someone who loves my children and appreciates my husband. Someone who rejoices with my triumphs and hurts because of my disappointments. Someone who doesn't have a quick word of advice or instruction, but will hear me out and try to understand before rushing to fix it. Someone who will drop the mundane long enough to come to my side, but not attempt to rescue me from God's discipline. My friend would have a sense of humor and a shared interest in the things I love most: music, books, poetry, seashells, rainbows, birds, walks in the country, the ocean and the sunshine. My friend would pray for me in hard times and praise God with me in good ones.

I realize this is a hard bill to fill. People aren't perfect, so don't expect perfect friendships. At times you'll have to extend a little grace to your friends. My classified ad is simply a word picture to strive toward. On our own we don't have the tools to be great friends. We need help from God, our perfect example of a friend. There's a line about friendship in the Neil Diamond song, "Travelin' Salvation Show," that makes this point clearly. Diamond sings that you have to reach up one hand to God as you reach out the other hand to help your brothers (in our case sisters). That will be necessary if we are going to help our friends survive the emotional trials that come from living. On our own we don't always have the strength or the confidence or the selflessness to be good friends. That kind of power comes from God. By asking God for these qualities, He will faithfully provide them in abundance. He's done it for me whenever I've asked. I know He will do the same for you. Especially if you are asking for the sake of your friends.

To a Friend*

You entered my life in a casual way,
And saw at a glance what I needed;
There were others who passed me or met me each day,
But never a one of them heeded.
Perhaps you were thinking of other folks more,
Or chance simply seemed to decree it;
I know there were many such chances before,
But the others — well, they didn't see it.

You said just the thing that I wished you would say,
And you made me believe that you meant it;
I held up my head in the old gallant way,
And resolved you should never repent it.
There are times when encouragement means such a lot,
And a word is enough to convey it;
There were others who could have, as easy as not —
But, just the same, they didn't say it.

There may have been someone who could have done more
To help me along, though I doubt it;
What I needed was cheering, and always before
They had let me plod onward without it.
You helped to refashion the dream of my heart,
And made me turn eagerly to it;
There were others who might have (I question that part) —
But, after all, they didn't do it!

— Grace Stricker Dawson

*Grace Stricker Dawson, "To a Friend," *The Best Loved Poems of the American People*, Hazel Felleman, ed. (Garden City, NY: Doubleday, 1936).

Reflecting on My Face as a Friend

Proverbs 17:17

How is the biblical view of friends different from the world's?

At what times does a friend love?

When was a time you wanted to leave because the going got a little too rough with a friend? What kept you there?

Proverbs 18: 24

What does this concept mean to you?

What would a family member be willing to do for you?

How can a friend treat you like a sister?

Proverbs 27:6

How can wounds be good or helpful?

Is it easy for you to be wounded by a friend?

What must be first developed in a friendship before you could accept this wounding as good and helpful?

Do you want a friend who tells you the things you want to hear or the things you need to hear? Is there a place for both?

John 15:13

This could mean literally dying. But how else can you give your life to your friends? Name practical suggestions.

In what ways could you better stretch yourself for a friend?

Hitting the Books

I was sitting at my desk in our newspaper office when a group of four college seniors dropped by at the urging of their business professor. Introducing themselves, they told my publisher about their semester assignment. The students were to develop a marketing strategy for a local business and hoped my publisher would be interested. Always wanting to help young people with their education, the boss agreed to participate in the project.

"We'll need to interview you four times this semester," one of the students volunteered. "Can we set up the first appointment today?"

The date was established and the students left. When the designated appointment time rolled around, the students didn't show. The publisher called to make sure everything was alright. It was, but there were other more pressing things to do, they explained. So, another date was set. It, too, came and went without an appearance from the college group. A telephone interview was conducted instead, and a project was mapped out.

As the semester progressed, our office heard nothing from the business students. It became apparent they were merely seeking to fill a class requirement. They had no real interest in solving a marketing concern for our newspaper or in seeing our company prosper. They simply wanted a grade so they could move on to the next class and eventually wind up with a piece of paper releasing them into the world of employment.

We received their final project in the mail as the semester was winding down. The publisher and I wondered how these students could have developed a project

with so little input from our office. We couldn't wait to see how these young geniuses would convince their professor they had helped us because we had not seen hide nor hair of them since that first, brief encounter. My boss tore open the manila envelope and took out a beautiful, computer-generated, 25-page report. It was impressive — so many charts, graphs and statistics.

There was only one problem: the entire project was a lie. The students had not accomplished even one of the things in their report. They had not made suggestions for company improvement. They had not recommended new software. They had not devised schemes to boost circulation. Yet their report said they had done all these things. Their conclusion stated that while they had proposed many creative and innovative ideas, our newspaper staff had declined implementing any of them. The publisher and I had a good laugh. How could we have refused their suggestions when we were never given any?

My boss called the professor who was overseeing the group to report the blatant fabrication. A few days later one of the students called our office hopping mad that his lie had been exposed. He was angry to have received a 'C' grade instead of "his 'A.'"

"You got a 'C'?" my boss responded. "Consider yourself fortunate. I'd have given you an 'F.'"

These college-aged adults had forgotten that employers desire attributes which can't be gleaned from college textbooks or contrived on a computer. Professors instill knowledge — but integrity, dependability and enthusiasm for a task are the responsibility of each student. I hope that since our encournter with them, this group learned to tell the truth, ask questions, communicate, be punctual, take initiative and stand by their word. I'm sure by now they have discovered the world does not owe them anything. An education is a necessary start. But without hard work and determination, it can also mean the end. A diploma is a ticket to the future only if the graduate is willing to continue learning and growing and being responsible.

I love books. Too many books, too little time — that's my motto. Give me a day off and you'll find me in the library or at the corner bookstore or on my back porch with a book under my nose. Reading takes me places I wouldn't otherwise get to visit. Books introduce me to real life heros and interesting fictional characters. They provide a wealth of learning opportunities and stir my imagination. Reading is a female heritage in my family.

My great-grandmother knew all the Old Testament Bible stories by heart. My grandmother devours books. Although macular degeneration has stolen her sight, she continues to "read" several audio-taped books each week. When I was a child, my mother took me to the library once a week. Each summer she selected books and read to my sisters and me for an hour a day, even after we were old enough to read to ourselves. I hope my children will also love books so our family learning legacy continues.

Strange as it may sound, the most frustrating verse in the Bible to me is John 21:25, "Jesus did many other things as well. If every one of them were written down, I suppose that even the whole world would not have room for the books that would be written." Don't you wish all those books would have been written and the life of Jesus told a little more completely?

God created people with a desire for knowledge. Adam and Eve's home was the most beautiful, perfect garden imaginable. God planted the garden with plants and flowers and many kinds of trees. Some trees bore mouthwatering fruit. Adam and Eve were told they could eat anything in the garden — a vegetarian's dream buffet — except from the tree of the knowledge of good and evil. When the serpent came along to tempt Eve, it is interesting that he used food (but that is another subject) and knowledge.

"God knows that when you eat of it your eyes will be opened, and you will be like God, knowing good and evil," the serpent said regarding the forbidden tree.

Genesis 3:6-7 tells us, "When the woman saw that the fruit of the tree was good for food and pleasing to the eye, and also desirable for gaining wisdom, she took some and ate it. She also gave some to her husband, who was with her, and he ate it. Then the eyes of both of them

were opened, and they realized they were naked; so they sewed fig leaves together and made coverings for themselves."

The saying, "Ignorance is bliss," must have started with Adam and Eve. There they were, blissfully running naked through a beautiful garden, munching delicious produce. One bad choice later and newly acquired knowledge leads to shame and guilt. The first couple passed up eating from the tree of life (which would have resulted in eternal physical life) to eat from the tree of knowledge. By doing so they put a higher premium on understanding life's mysteries than living in eternal earthly bliss.

Martha's sister, Mary, also loved learning. While Martha scrambled about preparing dinner for Jesus and his disciples, her sister "sat at the Lord's feet listening to what he said" (Luke 10:39). This irritated Martha and she whined about it to Jesus. To Martha's dismay Jesus commended Mary for her student attitude. Mary knew there would always be time for cooking and cleaning. But the window for learning from The Teacher was small. She wasn't about to let it get by her no matter how much her sister complained.

The fact that God gave us written instruction in book form proves He expects us to read and learn. Since very few, if any, of us could memorize the entire Bible by reading it once, God also expects us to continue studying and learning. Knowledge is not acquired overnight. It takes diligent study and motivation to achieve.

In Bible times Jewish girls were not permitted to go to school. While the boys studied, the girls learned to cook and care for a home. There are still cultures today where females are not allowed formal education. But for most modern-day women in developed countries, education is a right, a responsibility and a tremendous opportunity. In

America boys and girls begin their education starting with preschool or kindergarten and working their way up through high school. Higher education — college or vocational school — is encouraged nowadays to secure employment. Women can achieve whatever level of education they desire as long as there is money to fund it and a desire to pursue it. Knowledge is commonly seen as a means to an end. Without an education, the chance for a good-paying job is usually short-circuited. To be successful in a career, women today must diligently pursue education.

In recent history American girls were not expected or encouraged to seek higher education. Most believed they would marry, raise children and be supported for life by their husbands. Even if she never formally uses a college degree, it is wise for a woman to have one. We don't plan on staying single, getting divorced or becoming a widow, but one never knows. If any of these situations occur, a woman should be prepared, not caught off guard financially. How will you support your children if you suddenly become a single parent? In order to maintain your present lifestyle, will you need to marry again once your deceased husband's life insurance runs out? Can you get a job with benefits next week if financially forced to do so? Without a college education the chances are slim.

There are keys to receiving an education. "Apply your heart to instruction and your ears to words of knowledge," reads Proverbs 23:12. Simply showing up for class is not enough. Even the best teachers can't impart knowledge if their students aren't willing to apply themselves. With the rising costs of education students are wasting their money if they don't have it in their hearts to learn.

Ezra knew what it meant to be a determined learner. The Bible calls Ezra "a teacher well-versed in the Law of Moses, which the LORD, the God of Israel, had given,"

(Ezra 7:6). Before he could teach the Law, however, he first had to study and learn it. Ezra 7:10 reveals, "Ezra had devoted himself to the study and observance of the Law of the LORD, and to teaching its decrees and laws in Israel." A good student consistently studies, applies what she learns, and then teaches it to someone else. Had Ezra not been devoted to his learning, he would not have acquired enough necessary knowledge of God's Laws to perform them and pass them on to others.

A student's attitude about learning is critical. Too many teachers endure rude, disrespectful comments from students who think they already know it all. Students are in school to learn. Teachers are there to teach and they deserve respect while doing so. "A student is not above his teacher" (Matt. 10:24). No one knows everything; there is always room for additional learning. In fact, learning is a lifelong process that should never stop. Proverbs 9:9 is a good verse to remember: "Instruct a wise man and he will be wiser still; teach a righteous man and he will add to his learning." It all depends on the attitude you bring to class. "The heart of the discerning acquires knowledge; the ears of the wise seek it out," (Prov. 18:15). In addition to a backpack of books you need to carry a humble attitude, attentiveness and a hunger for knowledge to class.

There are many avenues for learning in today's society — college, vocational or technical school, books and manuals, correspondence courses, the Internet. But a woman (or man, for that matter) is not truly educated unless she has studied the Bible as well. Proverbs 9:10 states, "The fear of the LORD is the beginning of wisdom, and knowledge of the Holy One is understanding." The wisdom of man will impact your time on earth. The wisdom of God guides you through this life and makes an eternal difference

to your soul. Solomon, the wisest man who ever lived, knew the value of learning. In the book of Ecclesiates we learn that he devoted himself to study and to exploring by wisdom all that was done under heaven.

Solomon also learned that worldly knowledge comes with an emotional price tag. "'I have experienced much of wisdom and knowledge.' . . . I applied myself to the understanding of wisdom, and also of madness and folly, but I learned that this, too, is a chasing after the wind. For with much wisdom comes much sorrow; the more knowledge, the more grief" (Eccl. 1:16-18). Just as Adam and Eve discovered before him, Solomon realized that knowledge sometimes produces a reality check, which in turn results in sadness. I subscribe to a news magazine. I also read a daily newspaper. Most of the articles reveal grisly acts of human violence or despairing accounts of human frailty. Reading these articles educates me about those I share the planet with, but they also bring sorrow to my day. However, while knowledge sometimes stirs our hearts to sorrow, it also prompts us to be proactive concerning what we have learned. If we don't know, we can't help. Therefore, knowledge can also lead to change and betterment.

While knowledge of the world often discourages, God's wisdom gleaned from the Bible does not. It rejuvenates the reader and charts a positive life course. Solomon concluded that worldly knowledge "wearies the body," but godly wisdom is "a good thing and benefits those who see the sun. Wisdom . . . preserves the life of its possessor" (Eccl. 7:11-12). We need to balance worldly knowledge with God's wisdom. Doing this requires effort. Godly wisdom takes a lifetime to study and understand.

Ever since He delivered the Ten Commandments to Moses, God has directed us to study His ways. In

Deuteronomy 5:1, people were commanded to learn the decrees and laws given by God and to follow them. Before crossing the Jordan River into the promised land, God told Joshua, "Do not let this Book of the Law depart from your mouth; meditate on it day and night, so that you may be careful to do everything written in it. Then you will be prosperous and successful" (Josh. 1:8).

If you are in the process of training for a career, you probably hope to become prosperous and successful. Going to class, doing homework, studying for tests and writing papers will help you pass necessary courses on the road to a degree. But doing those things doesn't guarantee job security and career success. Scoring well in school may open some doors for you, but employers are also looking for character and heart, qualities not taught in textbooks. They are taught in the Bible, however. If you want to be truly successful, you must study God's Word along with your college manuals.

There is a danger in acquiring only man's knowledge. "We know that we all possess knowledge. Knowledge puffs up, but love builds up" (1 Cor. 8:1). I live in a college town. That means my community is filled with highly educated men and women. We could wallpaper the state of Texas with all the degrees in my town! And there are plenty of folks who are puffed up — a little arrogant — because they have acquired so much knowledge. I wholeheartedly support education, but while learning is always valuable, knowing truth is more worthwhile. As a writer, I can tell you that anyone can write anything and someone somewhere will believe it, even if there isn't a shred of truth in it. We have truth found in God's Word. All other information is to be assimilated and questioned before being applied.

In closing the book of First Timothy Paul warned, "Timothy, guard what has been entrusted to your care.

Turn away from godless chatter and the opposing ideas of what is falsely called knowledge, which some have professed and in so doing have wandered from the faith" (1 Tim. 6:20-21a). In some instances worldly learning poses a dilemma for Christians because textbooks often contradict biblical principles.

I remember a young man in my congregation who eagerly headed off for his first year of college. His goal was to become a science teacher. To get there, he had to take many science courses. When he returned for the summer after his first two semesters of study, he was anxious to divulge all he had learned. It became evident that this honor student had hungrily digested what his professors and textbooks offered. The problem was that much of the information conflicted with his Christian values and beliefs.

"Are you going to teach your students evolution as fact or theory?" I asked him.

"Well, I've thought about that," my young friend said. "I know that God made everything, so I believe that He also dictated the evolutionary process. From studying science this year I now think that evolution did happen over millions of years but that God designed the process."

"So what do you do with Genesis?" I posed.

"I plan to spend the summer working that out," was his response. "Maybe God just didn't tell us all the steps He used, and maybe He used figurative speech while writing Genesis. I think Genesis can probably be merged with evolution."

I cautioned this young man to view the Bible more credibly than his man-written textbooks. The Bible is the first place we need to seek answers. We should not take man-made theories and try to make the Bible fit them. Instead, we uphold God's Word first and then test all other knowledge against it. Truth needs to be guarded so

we can recognize opposing ideas. As Paul stated, there are many who have wandered from the faith because they were more eager to soak up worldly knowledge than the wisdom of God.

When life is over, it won't matter how much textbook knowledge you have. What will be most valuable then is having known the teachings of Jesus.

> There is a judge for the one who rejects me and does not accept my words; that very word which I spoke will condemn him at the last day. For I did not speak of my own accord, but the Father who sent me commanded me what to say and how to say it. I know that his command leads to eternal life (John 12: 48-49).

Back in Old Testament times there were no Bible bookstores. Each person could not own her very own copy of the Scriptures. God's laws were written on a scroll or tablet and carefully guarded. The Jews collectively gathered at certain times to hear Scripture read. There were also no microphones, so they had to be especially attentive. As long as the leaders were spiritually minded, the Law was well preserved and protected. But whenever an ungodly king or leader came into power, the Law was disregarded and God's words were vulnerable to loss.

When Josiah became king, his reign followed on the heels of ungoldy and wicked kings. Josiah "did what was right in the eyes of the Lord and walked in the ways of his father David" (2 Chron. 34:2). Josiah began seeking God at a very young age. When he learned God's ways, he purged his land of the idolatry that had prevailed under previous leadership. He also had the temple, which was in shambles, repaired so the people could once again have a house of worship.

While the carpenters were making repairs and restoring the temple, they found the Book of the Law of the

Lord that had been given to Moses. Blowing the dust away, Hilkiah, the priest, took the treasure to King Josiah.

> When the king heard the words of the Law, he tore his robes. He gave these orders to Hilkiah . . . "Go and inquire of the LORD for me and for the remnant in Israel and Judah about what is written in this book that has been found. Great is the LORD's anger that is poured out on us because our fathers have not kept the word of the LORD; they have not acted in accordance with all that is written in this book" (2 Chron. 34:19-21).

Josiah's heart was open to God's teachings. He knew the Lord's Laws were by far the most important pieces of information he could deliver to the Jewish people. He gathered all the people from the least to the greatest and read the words of God aloud. Josiah made a personal pledge to follow all God's commands and decrees and asked that his constituents do the same. As long as Josiah was king, the people followed the Lord and were blessed.

There is an important lesson here for us. When we trust worldly knowledge, there are no guarantees. Trouble may even follow. But, if we, like Ezra, get excited about discovering God's decrees and His written message of love and forgiveness, we will be blessed. That doesn't mean our lives will be perfect or that nothing bad will ever happen. The result, though, will be a renewed sense of self-worth and a peace that passes all understanding. Remember, knowledge will pass away (1 Cor. 13:8), but God's wisdom will remain.

If you are in school, continue your education. Keep reading and learning and discovering new ideas. But hold three books in the highest esteem. Read the Bible. Be aware that your deeds are written in angelic books in heaven. "And I saw the dead, great and small, standing before the throne, and books were opened. . . . The dead

were judged according to what they had done as recorded in the books" (Rev. 20:12). And, make sure your name is written in God's Book of Life. "Nothing impure will ever enter it [The Holy City], nor will anyone who does what is shameful or deceitful, but only those whose names are written in the Lamb's book of life" (Rev. 21:27). Don't let these three books escape your attention. Eternity — your eternity — is built upon them.

Reflecting on My Face as a Student

2 Peter 1:5-8
> What relationship does knowledge have with these other qualities?
> What kind of knowledge do you think is spoken of here?
> What is the by-product of knowledge?

Romans 1:28-31
> What happens if you don't retain godly knowledge?
> How can continuing to grow in biblical knowledge protect you?

Nehemiah 8
> What was the people's response to the Book of the Law?
> Do you study the Bible with the same intensity?
> Have you noticed how biblical knowledge brings joy?
> Why did the Law cause the people to weep? (vs. 9)
> Has reading the Scripture ever caused you to cry? Why?

Isaiah 44:24-25
> Which do you think deserves more invested time — the world's knowledge or God's truth? Why?
> How does God turn man's wisdom into nonsense?

2 Timothy 3:6-7
> Why do you think women were singled out in this verse?
> What kept them from acknowledging truth in their quest for knowledge?
> How will you keep from being a victim of false teachers?

Isaiah 54:13
> Are you leaving behind a legacy for godly learning?
> What will be the result for your children and grandchildren?

Who's the Boss?

⚍‡4‡⚎

Going to the grocery store is not my favorite chore. Some people like to roam up and down the aisles searching for exotic new food items. To them, grocery shopping is like a culinary treasure hunt. I see it as an ordeal. First I make a list. Then I sort through my stack of coupons, matching them up with that week's sale items. On average it takes me about an hour to walk the aisles and find everything on my list. After checking out I have to load my purchases into the car, unload them from the car and into the house, take them out of the sacks and put everything away in my kitchen. For me grocery shopping is about a three-hour project. When I'm through, I'm usually too exhausted to start cooking anything.

I'd rather order a pizza. But I refrain.

Not long ago, while I was shopping at my neighborhood grocery store, things were going pretty much as expected. As usual I entered the checkout lane about an hour after marching through the automatic front door, armed with a fistful of coupons. Seeing my overflowing cart, the checker reached for her intercom phone and called for a sacker. A teenaged boy energetically made his way to my lane. No more than five feet tall and tipping the scale at a hundred pounds if he was lucky, this boy wore the usual white shirt and tie. He greeted me, his blue eyes peering through extremely thick eyeglasses held on with a backstrap. "Great," I thought to myself, as I read his little white name tag. "A new kid. This will probably take longer than ever today." To my surprise Josh dug right in, quickly filling my sacks.

"Will this be paper or plastic?" he asked, his broad grin revealing a mouthful of shiny, metal braces. "Looks like you'll be able to fix a mighty good supper for your family tonight."

I nodded absentmindedly as I wrote out the check.

"Ma'am, this box of waffles is ripped," Josh informed me. "I'll run get you another one."

Before I could respond, Josh raced off to the freezer section. Quick as a flash he was back, waving a nondefective box of waffles. Wow, this store hired Speedy Gonzales and dressed him up as a teenage boy!

Rarely do I have a carryout helper who makes any meaningful conversation with me. But I never had Josh before. He happily rattled on and on, starting like most people do with the weather.

"Sure is a nice day," he announced as he pushed the cart to my van. "Yep, it sure is a nice day to get to carry people's groceries out to their cars."

I glanced over to see if Josh was being sarcastic. His childish smile and purposeful stride behind the cart told me his attitude matched his words. As he loaded sacks one by one into my van, Josh chattered about this thing and that.

"Bet you like driving a nice van like this," Josh said, continuing to load my food. I looked at my nine-year-old minivan with the woodgrain peeling off one side and dirt covering the entire body. "Yep, it sure must be nice to have such a nice big van to get all your groceries in," he continued. "Look how easily they all fit back here. I don't even have to bend over to load your car. It sure is a pleasure to load these sacks into this kind of vehicle."

Was this kid for real? What was he so happy about? Didn't he know he was a measly grocery sacker — low man on the supermarket totem pole? Practically last on the food chain? Hadn't he learned yet that loading people's groceries was work and that work wasn't meant to be fun? Maybe he had watched "Pollyanna" a few too many times.

"You seem to really enjoy your job," I said to Josh as he put the last sack in my van and slammed the hatch shut.

"Oh, yes! I sure do," he responded. "Every day I get to dress up and arrange food in sacks. I get to help nice people like you to their cars. I get to talk to lots of people every day about all sorts of things. And sometimes they even let me bring in all the carts. It's like driving a great big train into the store. Yep, I sure do like my job!"

Josh beamed from ear to ear as he recalled each chore. His smile was contagious; I couldn't help but smile back. Hearing him describe his job so positively made me see the grocery store chore in a whole new light. Work is all in what you make of it, Josh taught me that day. And any day on the job can be joyous if you look at it with grateful eyes. Thanks, Josh.

Who's the Boss?

All women work. I thought I would say that right up front. Whether she's at home all day with small children, running a business from the house, or punching a time clock for someone else, I don't know any woman who does not work in some capacity. And from what I see, women are hard workers. Some of the most tiring days of my life were spent as a stay-at-home mom. During those 12 years I was commonly asked, "Where do you work?" or "What do you do?" When I explained that I stayed at home to raise my kids, the next most often question was, "Aren't you bored?" Sometimes, but then aren't all jobs boring sometimes? The funniest question came from an uninformed single woman. She asked me, "Do you work or do you go to school or do you do nothing?" Like I said, she was uninformed.

This chapter is not a debate about working at home to raise children versus establishing a career outside the house. Both are worthwhile endeavors. This chapter is about being the best employee you can be no matter where your place of employment is located. Most women will experience a variety of jobs during their lifetime. Beginning as a teenager, I have worked as a babysitter, a corn detassler (now there was a JOB), a fast-food server, a secretary, a telemarketer, an aerobics instructor, a wife and mom, an elementary remedial math instructor and a columnist and reporter. If you take the time to count them, you will probably find several work hats in your life-time wardrobe as well. Although women are often called to work in numerous capacities, the principles of being a good employee remain the same. The job may change, but your motivation shouldn't.

So what makes a valuable employee? I asked a few bosses what they look for when hiring new help. The list they gave me is not surprising. Honesty, reliability and

trustworthiness took top billing when it comes to building a work force. Hard-working, dedicated and loyal followed close behind. Employers want workers who are confident, yet willing to admit mistakes. They like initiative but also value the ability to take and follow directions. Other positive employee attributes include poise, being responsible and respectable, effectiveness at communicating, and being committed to the task at hand. Notice something familiar about these valued qualities? Employers want their employees to work by biblical principles. Of course, before you can work by them, you must possess them.

Wouldn't the world of employment be a wonderful place if every company was run by biblical standards? If you have a believing boss who runs her business by God's principles, be grateful. For most women that is simply not the case. The workplace is often where faith gets tested and standards are sometimes compromised. Issues surface on the job that regularly challenge godly integrity. For example, should you attend an office party held in a bar? Will you order a few drinks and pray that no one from church sees you? How will you respond if the boss propositions you? Will you report a coworker who slips a few office supplies into her purse? Will you be tempted to pad your travel expense account? How will you react if falsely accused? How will you deal with company gossip? When asked to alter a few numbers that don't quite add up, will you do it? Will you stay late and work off the clock even though your son asked you to attend his soccer game?

Unfortunately these dilemmas are common. Christian women need to think through such situations before they arise and formulate a game plan. It is ironic that while most employers want their staff to possess solid values, they sometimes allow circumstances to compromise those

very standards. Standing on biblical integrity is an around the clock lifestyle. We should not switch the standard off and on whenever it seems convenient or most popular. You don't leave your Christianity on the office doorstep each day and pick it back up again before driving home. That part of you should be invited into the workplace. Because the work world constantly tugs at your conscience, it is important to be well grounded before entering any employment setting. By purposing your behavior beforehand, there will be less chance of caving in to temptation later.

God intended for people to work. It is good for us. King Solomon, the wisest person who ever lived, sought meaning in many things. Through a string of disappointments he learned that great intellect, many riches, political power, and hoarded possessions are all meaningless. Solomon reached the conclusion that only two things are worthwhile endeavors: fearing God (Eccl. 12:13-14) and hard work.

> Then I realized that it is good and proper for a man to eat and drink, and to find satisfaction in his toilsome labor under the sun during the few days of life God has given him — for this is his lot. Moreover, when God gives any man wealth and possessions, and enables him to enjoy them, to accept his lot and be happy in his work — this is a gift of God. He seldom reflects on the days of his life, because God keeps him occupied with gladness of heart (Eccl. 5:18-20).

Mankind was meant to work and to gain satisfaction from that work. Certain studies reveal that elderly people in this country are several times more likely to become depressed than younger people. Many factors were examined, including how older people spend their time. For most the days are long and lonely. They sit in front of the

television or by the telephone waiting for something to do. On the other hand, some of the happiest older people are those who decide to work part time. Their jobs allow them interaction with other people and renewed productivity. They report better health and happier lives than their nonworking counterparts. Maybe we, as a society, need to rethink retirement and social security. If Solomon was right, we are doing our older people a disservice by expecting them to leave the work force at 65 or sooner. We might be cheating senior citizens out of continued satisfaction in their work.

Another American issue currently being reexamined is welfare. Certainly there are people unable to work because of physical or mental limitations. But there are people on welfare who could and should be working. The welfare system was intended to help people, but has ended up hurting many of them. Few want to accept public assistance and most feel badly about doing so. Entitlement programs can become a trap, holding people in the jaws of unemployed oppression. The Bible indicates that God expects people to work for a living. In 2 Thessalonians, Paul writes,

> We were not idle when we were with you, nor did we eat anyone's food without paying for it. On the contrary, we worked night and day, laboring and toiling so that we would not be a burden to any of you. We did this, not because we do not have the right to such help, but in order to make ourselves a model for you to follow. For even when we were with you, we gave you this rule: "If a man will not work, he shall not eat" (2 Thess. 3:7-10).

Paul knew that those he ministered to would benefit from seeing him work for his food. He wanted them to do the same. The Thessalonian Greeks thought manual labor was degrading. They were reluctant to roll up their

sleeves and get to work. With too much time on their hands, they became idle and gossip spreaders. "We hear that some among you are idle. They are not busy; they are busybodies. Such people we command and urge in the Lord Jesus Christ to settle down and earn the bread they eat," Paul wrote in 2 Thessalonians 3:11-12. In addition to putting food on the table, hard work also keeps us from sin. If you are busy working, you will have little time for laziness or gossip. Employment, therefore, keeps us out of trouble and well fed.

In the Old Testament, Ruth and her mother-in-law, Naomi, were perfect candidates for public assistance. When their husbands died, these women suddenly found themselves without money for food. They left their familiar community and traveled to Bethlehem where the barley harvest was just beginning. Although new to town, Ruth, a young woman, decided to go into the fields to provide food for herself and her mother-in-law. The fields did not belong to Ruth and she had no right to the crop. But the law of Moses instructed landowners to leave what little grain the harvesters missed so the poor, the alien, the widowed and the fatherless could glean some food for their needs. Even the poor in those days were expected to work for their food; the harvesters did not carry a part of the crop directly to the homes of the needy.

When Boaz, the landowner, saw Ruth gleaning barley, he asked his foreman who she was. The foreman replied, "She is the Moabitess who came back from Moab with Naomi. She said, 'Please let me glean and gather among the sheaves behind the harvesters.' She went into the field and has worked steadily from morning till now, except for a short rest in the shelter" (Ruth 2:6-7). For the rest of the harvest Ruth endured the backbreaking work of harvesting grain. She gratefully and tirelessly gathered the stalks,

pounded the grain away from the chaff, and carried it back to her mother-in-law. "So Ruth gleaned in the field until evening. Then she threshed the barley she had gathered, and it amounted to about an ephah. She carried it back to town, and her mother-in-law saw how much she had gathered" (Ruth 2:17-18). Ruth was not a whiner. She saw her mother-in-law starving. She herself was hungry. Ruth did not wait for someone else to meet her needs. There were no unemployment payments nor social security benefits for widows at that time. Ruth knew if she and Naomi were going to have food, she must go out and work. Reading through the book of Ruth, we see that God blessed Ruth's determination to work hard and her dedication to Naomi.

The Bible outlines attitudes employees should possess. I doubt any of us today would refer to ourselves as slaves, although at times we may think of our bosses as slave drivers. In biblical times Paul wrote special instructions for slaves. Even though we are paid for our jobs, his guidelines can still be applied. Paul commanded slaves to treat their masters with respect, awe and sincerity. He urged them to obey their masters the same way they would obey Christ.

> Obey them not only to win their favor when their eye is on you, but like slaves of Christ, doing the will of God from your heart. Serve wholeheartedly, as if you were serving the Lord, not men, because you know that the Lord will reward everyone for whatever good he does . . . (Eph. 6:6-8).

How would your employer respond if you worked wholeheartedly this week? Would he notice a difference if you worked as if serving God instead of a corporate boss?

The truth is, you have two employers: The one who signs your paycheck and God, whom we serve in all that we do. When I was at home with my children, I memorized Colossians 3:23-24. "Whatever you do, work at it

with all your heart, as working for the Lord, not for men, since you know that you will receive an inheritance from the Lord as a reward. It is the Lord Christ you are serving." In those days I received many rewards from my children. There were daily hugs, kisses and "I love yous." There was the satisfaction of a squirmy little body settling down in my lap to hear a book. There were nature walks in the park and rocking new babies to sleep. But there was also time spent scrubbing floors, washing mountains of diapers and dirty dishes, and enduring long waits with impatient children in the pediatrician's office. There were lonely, cold winter days when the walls of our home seemed to close in around me and my kids. It was during those times that I reminded myself I was serving God.

God has given each of us jobs to perform, tasks to accomplish and skills to accomplish them with. When Moses organized the Israelite community to build the tabernacle, he called upon "[a]ll who are skilled among you . . . to come and make everything the Lord has commanded . . ." (Exod. 35:10). And so they came. Men and women brought their resources, their time and their talents to work for God. Some women spun goat hair for curtains, others mounted jewels. Craftsmen used their abilities to design artwork. Collectively the people pooled their talents to build furniture and construct an altar. They crafted a courtyard and stitched the priestly garments. Time after time the Bible states it was the Lord who had given these abilities to His people and He expected them to use such talents for His purposes.

Think about your job. Maybe you are good with numbers and have an eye for detail. Maybe you have effective communication skills and can help others solve problems. Maybe you have compassion for children or animals. Maybe you have the intellect for research. Maybe you have

a gift for writing your thoughts into words or using your hands to create beautiful art. Or maybe you understand the workings of computers. Whatever your ability might be, it was given to you by God. On the job you are called to use your talents to glorify Him. If we remember that our jobs and the talents we possess are from God, we will conduct ourselves professionally on the job. If tempted to swipe a few office supplies, we will decide against it since God blessed us with the job. When gossip surfaces, we won't participate because we know God is our boss and He doesn't approve. If you find a male coworker attractive, you will remember to honor God with your body and go no further. See the benefit of realizing you have two bosses — one earthly and one heavenly? It makes employment decisions so much easier and more beneficial.

My husband and I own and operate a small, community newspaper. After we had produced our first issue several years ago, Michael came into our office with a challenge. In his late 20's, Michael was a little rough around the edges upon first inspection. Powerfully built, he sported a blonde crew cut and a heavy Brooklyn accent. He wore shorts and work boots no matter what the season. Michael was a blonde, '90s kind of Rambo.

"Hey, are you the owner?" Michael waved a newspaper at my husband.

Bert introduced himself and me to Michael, unsure what this visit was all about.

"Yeah, well, I have something to ask you. Are you guys Christians?" No one could accuse Michael of beating around the bush.

Bert assured him we were.

"Well, don't you think you ought to have a Bible verse in this paper somewhere then?"

"That's a good idea," Bert said, flipping the front page of the newspaper over. "We could put it right here on page two, our editorial page."

"That would be okay, yeah," Michael said. "But don't you think God deserves our best? Don't you think He deserves to be on the front page, say right about here?" He pointed to a prominent spot right under the masthead.

Bert hesitated, swallowing hard. We were new in town. We had no idea the religious makeup of the community or if atheists outnumbered believers. Our plan had been to produce a quality newspaper for a community lacking a voice piece. Politically our original goal was to be accepted, and in the process to sell papers. But we couldn't argue with Michael's request. He was right, and Bert and I both knew it. It was a risk we would have to take — a matter of faith that we needed to entrust to God. Bert told Michael that starting with the second issue, there would be a Bible verse on the front page. Michael smiled and Bert thanked him for the suggestion.

The next week we selected a Scripture for page one, wondering if our desire to please God would be accepted by our readers. To our surprise and great pleasure we received several calls thanking us for including the Bible in our weekly newspaper. Michael had been right. God does deserve the most prominent spot in anything we do. He deserves the glory and credit for our accomplishments. Bert and I realize God has provided us a great opportunity to be employed together doing something we both enjoy. He gave us the ability to work with people and use our talents to produce a well-received product. Ever since Michael reminded us of whom we serve, Bert and I now weigh our business decisions against the will of God. We try to fill the pages of our newspaper with news content, editorial stances and advertisements that will please the

Lord and not disappoint Him. We don't always make our readers happy, but we believe God is pleased with our efforts on the job. We also believe that as long as we put Him first, He will continue to bless our business.

To bring further glory to God, we should not allow our jobs to stand in the way of serving the church. When I worked at home, it was easy to regularly have people over for meals. Once I started working outside my home, the thought of entertaining or taking meals to sick people wasn't as appealing. But a job is not an excuse for neglecting ministry. The key is prioritizing and better planning. We know from Acts chapter 18 that Paul was a tentmaker. He did not give up tentmaking to become a missionary. Instead he used his job to meet people like Aquila and Priscilla to help him in ministry. I'll bet he also used it to witness to those ordering tents. If God has given you employment skills, it makes sense that He will also pick a workplace where you can be the most effective for Him. Look around. Do you have coworkers who could benefit from hearing the message of Christ? Ever invite your boss to church or a Bible study? Is your Christianity evident to those in your office?

When Paul traveled to Philippi, he encountered Lydia, a businesswoman from Thyatira. Lydia was a dealer of royal purple cloth. A Gentile, she was a worshiper of God, but had not been taught the gospel message. She was among a female group gathered by the river the day Paul arrived. When Paul told the women about Christ, Lydia responded to the message. Following her baptism she invited Paul and his fellow missionaries to her home. "'If you consider me a believer in the Lord,' she said, 'come and stay at my house'" (Act 16:13-15). Lydia could have kept silent hoping one of the other women would provide hospitality to Paul and his workers. After all, there was

cloth to sell and money to earn. But Lydia gratefully understood that her employment opportunities, coupled with a desire to do God's will, had led her to hear the message of salvation. She did not allow her busy work schedule to become an excuse for neglecting others. In fact, in Acts 16:40, Lydia also opened her home so Paul and Silas, after their release from prison, could meet with other Christians for encouragement. What an example for us!

God has given each of us separate abilities and opportunities to use them. We can choose to work for paychecks and promotions. Or we can please God by demonstrating His purposes in our places of employment. Paychecks and promotions are not bad. Christians promoted to high places can make great things happen. Paychecks take care of our families and fund church work. But they are not the bottom line. Wherever you work remember this: "[W]e are God's workmanship, created in Christ Jesus to do good works, which God prepared in advance for us to do" (Eph. 2:10). With this verse in mind you can be the best employee your boss ever hired. With your heavenly boss cheering you on your earthly boss can't help but take notice and be pleased.

Reflecting on My Face as an Employee

Proverbs 31:10-31

This woman worked inside her home and in the business world. Pick out all the examples of work she performed.

What was her character like?

How did her work ethic and character reflect on her family?

What was her motivation?

1 Thessalonians 4:11-12

What employment instructions are given here?

What are the benefits of such determined work?

Titus 2:9-10

Using the word employee instead of slave, how should we treat the boss?

How can your attitude at work affect your boss and coworkers?

1 Peter 2:18-23

If you are in a negative workplace and have no other employment opportunities at the present, what attitudes will help you survive the situation?

What will you need to overcome to be more like Christ in the workplace?

Colossians 3:23-24

Do you see your job as service to God?

If not, what blocks your view?

Committed to Love

⊰ ✝ 5 ✝ ⊱

His eyes followed her down the long aisle. A smile formed on his lips. She looked so beautiful in the flowing, white gown. Months of planning had slowly passed and now the big day had finally arrived. Their gaze locked as her father delivered her to his side. She took his arm. He gave her a wink of approval. Both turned to look at the minister as the wedding ceremony began.

I had been privy to this scene before. A perfect day for a perfect couple, perfectly decked out in perfect array. Even my own wedding had gone off without a hitch. No one fainted. None of the guests shouted, "I object." And neither my husband nor I forgot our well-rehearsed lines. Yes, weddings are romantic and memorable, probably even worth having, but I am afraid they are not very realistic. I sometimes wonder if we do young couples a disservice by starting them out on such perfect footing.

Take the wedding vows for instance. Those old tried and true vows sound impressive. But if you really listen, you will notice they are fairly vague. Since we've heard them dozens of times, their meaning is lost on most of us. "I promise to love, honor and cherish for richer, for poorer, in sickness and in health, being faithful only unto you as long as we both shall live." A vow is a promise, and before making any promise, people should understand specifically what they are pledging. When a couple is young, in love, and seeing their soon-to-be-spouse standing at the altar looking more beautiful than they ever have or ever will again, it's easy to promise anything and not really care what the words mean at the time.

As I watched this starry-eyed couple face each other and hold hands to exchange the vows we all know by heart, my mind began to drift. I mentally created a set of much more realistic vows for marrying couples:

The bride would begin, "I promise to love you even after you go bald, pack 25 pounds of blubber around your middle, watch hours and hours of television sports without talking to me, track car grease on the carpet, go hunting with the 'boys,' leave dirty clothes all over the floor, and work rotating shifts. I also promise to cook your favorite meals once in awhile, attend a football game with you and pretend to enjoy it, not nag you too much about helping around the house, and not be too upset when you miss our anniversary — again."

To which the groom would respond, "I promise to love you even when you get cellulite and varicose veins, complain of pregnancy backaches, overextend the credit cards, put a dent in the car, burn the roast, sleep in my flannel shirts, describe in detail how bad the kids were all day, and talk on the phone to your friends. I also promise to take you out to eat once every six months and compliment your cooking without reminding you of how my mother cooks chicken. I'll try to put the newspaper down during your attempts at conversation with me, and I'll tell you how beautiful you look when you are nine months pregnant."

Okay, so these may not be the most romantic words you have ever heard, but you'll have to admit they are realistic. My daydreamed vows spell marriage commitment much better than the ones so commonly heard. It's easy to memorize some rote, archaic phrases like everyone else has done before you and say them without feeling or any real understanding of their meaning. How much better off couples would be if they faced their wedding vows with the knowledge of what will most likely lie ahead. I don't expect many engaged couples to adopt my newly proposed vows for their actual wedding day. But wouldn't they make the wedding rehearsal a little more fun?

Most married women remember their wedding day. If the memory starts to wane, looking at the wedding pictures brings the image back into focus. If you have wedding pictures, dust them off and take another look. How did you feel on that special day? Some may recall feelings of nervousness and excitement. Most will remember feeling happy and in love. How do you feel today — five years, 10, 20 or 50 years later? Do you still feel exactly like the bride in the picture. So what changed?

Just like the opening story, few of us started out with a realistic picture of married life. Instead of examining the living, breathing, three-dimensional examples all around us — our parents, the neighbors, our grandparents, couples in and out of the church — we turned to romance novels and *Bride Magazine*. We believed our marriages would somehow be different, more blissful. On our wedding day we sold ourselves the dream of ongoing romance and eternal marital happiness. Soon, possibly even on the honeymoon, real life shattered the fantasy. As the wedding dress was packed away and the tuxedo went back to the bridal shop, we were left to juggle marriage with career and family. We had to decide who would take responsibility for each household task. And we adjusted to sharing all available living space with another human being who didn't see things on the same plane, mostly because he is male.

Chances are you didn't even hear your wedding vows. Let's face it, you weren't much in the mode for listening. And you probably would have agreed to practically anything just for the opportunity of spending the rest of your days with the love of your life. If you had been paying attention, you would have noticed that your wedding vows were actually quite sobering. For starters, "for better or for worse" is completely open-ended. Unless you experienced a wedding catastrophe, most anything will be worse than the exciting day you got married. After being on his best behavior that important day, "worse" could reveal that your husband slurps cereal straight out of the bowl, leaves the toilet lid up causing you to take a plunge in the middle of the night, shoves dirty underwear under the bed, or relentlessly channel surfs when you are trying to watch the TV movie of the week. Of course, there is also "better," like the day you bring your first child home

from the hospital. But realistically the "worse," compared to the wedding day, generally outnumber the "better."

What about "richer or poorer?" If a couple marries young, usually their days ahead will be "richer" and more financially stable, especially if both are working. But there is always the risk of financial loss and the reality of "poorer" in the years to come. During the course of a marriage it is possible to lose a job, experience a house fire or tornado, lose an investment, or have a crop drown out. Couples who wait until they are financially secure before marrying find their love tested when an unforeseen money woe appears. Money comes and money goes. There is no predicting it. And as marriage counselors attest, finances can produce much conflict between a husband and a wife.

As a couple gets older, "in sickness or in health" becomes a harsh reality. "In health" is no problem. It's the "sickness" part that can really try a relationship. We are all going to get sick. Fortunately, most illnesses are short-term. But without knowing what lies ahead, few brides ever consider how far their love will reach in the face of depression, addiction or a terminal or degenerative disease. It is easy to look at a handsome, able-bodied groom on that glorious wedding day and promise to love him in sickness and in health. At that moment the bride is thinking of colds and flu. But what about paralysis or head injury?

I know women who divorced their husbands when a cruel illness like Alzheimer's or multiple sclerosis entered their homes and their husband's bodies. I also know women who exemplified love and devotion by taking care of their terminally ill husbands as they lived out the last years of life "in sickness." If a married couple lives long enough, odds are that either the husband or the wife will

experience a major sickness of some kind. Illness is unavoidable and can be one of the biggest challenges a marriage will experience.

"To love and to cherish" means to prize, value and hold dear. All women want their husbands to pledge this vow from the heart. And, ladies, men want to be considered valuable, too. When we promise to "keep ourselves only for him," we are vowing to give up man-shopping. Starting with the wedding day, a bride becomes a one-man woman. No more cafeteria-style dating. No more men. This man is the package his bride takes home and pledges to live with no matter what or who else comes along. "From this day forth," means from now until forever. Depending on their ages when a couple weds, this could mean 40, 50, or even 70 years. "Until death do us part" could be a long, long time to live with another person.

These are the wedding vows, the promises that most brides and grooms make on the first day of their life together. They are sobering promises and should be carefully considered before hurriedly repeating them at the minister's direction. Even though most couples continue to make these pledges, currently more than half of all American marriages end in divorce. It appears many couples believe their vows can be undone. When tough times emerge, wedding day promises fly out the window and those who made them walk out the door, slamming it behind them. The devastation of divorce can be avoided. But it takes commitment, selflessness, unconditional love, forgiveness, realistic expectations and contentment on both the husband and the wife's part.

The way to successfully keep your marriage vows is through commitment. First you must commit to Him, before you can commit to him. In other words, without a commitment to God there is little basis for keeping your

commitment to your husband. Think about those wedding vows we've been discussing. Remembering that you pledged these ideals to God as well as to your husband will greatly impact your married life. It is one thing to break a vow with another human being, but it is much more serious to break a vow with God.

Genesis tells us that male and female were created in the image of God. We come into marriage as equal partners in God's eyes. "But at the beginning of creation God 'made them male and female.' 'For this reason a man will leave his father and mother and be united to his wife, and the two will become one flesh.' So they are no longer two, but one. Therefore what God has joined together, let man not separate," Jesus said in Mark 10:6-9. God brings two equal but very different individuals together to form a union. A husband and a wife become one entity in the eyes of God. When we marry, we are asking God to join us to one other person for the rest of our lives. If the couple is no longer two people but one being, they can no longer be separated back out into two separate parts. Divorced couples find it impossible to totally disconnect themselves from each other or the memory of each other, especially if they have children. When God joins something, it is stronger than superglue! No wonder widows and widowers often speak of losing a part of themselves when their spouse dies.

By leaving home and family to be connected to another person, we are pledging that the relationship with our spouse will supersede all other human relationships. Before he can be united to his wife, a man must leave his mother and father. This doesn't mean he permanently cuts himself off from his parents. It is simply a decision that from the wedding day forward his wife will become his most important human relationship. God bonds a man

and woman tightly through marriage. If a man (or woman, for that matter) doesn't commit to this bonding, his God-given counterpart will feel continually pulled apart at the seams. Those who have experienced this struggle can vouch for the pain caused by attempting to pull apart something that God permanently adhered. Trying to repeatedly tear away puts a tremendous strain on the relationship and results in damage. Couples planning marriage need to understand that their commitment is based first on God, then on each other. The marriage relationship comes before parents, siblings, friends, and even children. There is no other earthly relationship bonded so strongly by God.

If you think about marriage woes and foes, most of them boil down to selfishness. When my husband and I first married and began having babies, we unconsciously started keeping track of time spent with each other, the kids and pursuing individual interests. If he spent two hours away from the house playing basketball with his friends, then I demanded two hours of time doing something I enjoyed. If he watched a television program one evening while I bathed the kids, I expected a turn around of events the next evening. There is no other word to describe this than selfishness.

Philippians 2:3-4 reads, "Do nothing out of selfish ambition or vain conceit, but in humility consider others better than yourselves. Each of you should look not only to your own interests, but also to the interests of others." If you considered your husband's interests before your own, imagine the difference it might make in your marriage. We have already established that the husband and wife were created equal in the eyes of God. Society would have us believe this means the husband and the wife should each look after themselves. But what would happen

if the wife looked after the needs of her husband and the husband looked after the needs of his wife because both had decided to put the other's interests ahead of their own? We wouldn't need so many divorce lawyers, that's what.

Humility is the key to being able to put another person ahead of yourself. Being humble is not easy. It takes decision, practice and prayer to accomplish. Now you may be thinking, "Yeah, my husband will love this all right, but I'll be the only one giving." Maybe, but maybe not. Sit down with your husband tonight and repent of your past selfishness. Tell him how selfishness and a lack of humility have caused problems. Vow to him that it will be an ongoing struggle, but you want to change. When he hears your sincerity, chances are your husband will follow your example. But, remember, the goal is not to change him. You are only responsible for changing yourself. And it's only for yourself and the way you treat others that you are accountable before God.

Unconditional love is another key element in a successful marriage. We must love our husbands, not "if" or "because," but "in spite of." Loving him because he brought me flowers or if he remembers our anniversary is putting a condition on my love for him. Since we are joined together, God wants me to love my husband just because he is my husband. Even if he never did another nice thing for me, I am still called to love him — in spite of his shortcomings.

It is interesting to note that women must be trained to love their husbands (Titus 2:4). Unconditional love does not come naturally. It is not a feeling; it is a decision. Decisions take effort to fulfill. That dizzy feeling you felt for the anxiously waiting groom on your wedding day was the emotion of love. True and lasting love goes way

beyond emotion. It takes root deep in the heart and is expressed through commitment and dedication. When the tux comes off and the waistline expands and your husband gives in to a few bouts of slovenliness, true love goes past the physical to the soul of the man. Unconditional love says, "I love you forever no matter what."

A newly married bride is to learn this kind of love from older women in her life. These lessons might come from respectable older women in the church. They might be exemplified in a grandmother who has been married for 50 years. They might be seen by watching your mother serve your father. Younger women can't teach each other because they haven't experienced the challenges and trials that older married women have struggled through. The rewards would be great if churches would establish a mentoring system where older women pass on their wisdom of love to younger women. Such relationships cross generational lines to build stronger marriages and create a support system for young brides overwhelmed with responsibility. Mature women would also benefit as they see their experience and encouragement strengthening marriages in God's kingdom.

Once, while speaking to a ladies' Bible class, I asked those present to raise their hands if their husbands had never hurt their feelings. Not one hand went up. Even though they don't intend to, in time, all husbands will say or do something hurtful to their wives. Wives will do the same. Men and women rarely think alike, so misunderstanding and conflict are inevitable, and usually unintentional. Therefore we must learn to forgive and forget.

A relationship can be damaged if one or the other person insists on being hysterical or historical. Conflict is easier to resolve if everyone keeps calm and vows to seek resolution. Dragging up past issues or conflicts only makes

matters worse. Avoid making accusations like "you never," "you always," "you should have," and "why didn't you?" These words are loaded weapons meant to invoke past situations in order to make the other person feel inadequate or inferior. They are also used to gain the upper hand in an argument but have the potential to damage a relationship.

Colossians 3:12-15 ought to be included in every wedding ceremony:

> Therefore, as God's chosen people, holy and dearly loved, clothe yourselves with compassion, kindness, humility, gentleness and patience. Bear with each other and forgive whatever grievances you may have against one another. Forgive as the Lord forgave you. And over all these virtues put on love, which binds them all together in perfect unity. Let the peace of Christ rule in your hearts, since as members of one body you were called to peace. And be thankful.

These qualities would combine to make a great marriage. Especially notice the level of forgiveness we are to have toward others, including our spouse. We are to forgive as the Lord has forgiven us. Jesus died so we could be forgiven. He did not rise again only to say, "What is wrong with you people? I died for this sin and that sin — remember doing those things? — and now this is how you treat me?!" Yet this is the type of statement that sometimes surfaces during marital conflict.

Psalm 103:12 states, "[A]s far as the east is from the west, so far has he removed our transgressions from us." Since the east is at the total opposite end of the spectrum from the west, our sins have been completely removed from our lives. Next time your husband offends you, try removing his offense as far as the east is from the west. You won't be compelled to bring it up again, because it

will be totally out of your life. If God remembers your sins no more (Isa. 44:25), then who are you to hold the sins of your husband over his head?

Women need to be realistic about what their husbands are capable of being. I spent my early married life following several television soap operas. Gorgeous men, speaking charming, romantic words, filled the TV screen day after day. These men dressed fashionably, knew all the right moves and lines, and frequently whisked their women away on fantasy vacations. The soap opera life was a far cry from my own. Instead of sequined ball gowns, my closet was full of jeans and sweatshirts. I scrubbed floors on my hands and knees and soaked cloth diapers in the toilet while those soap opera women primped, shopped and attended galas. Their children were always conveniently asleep in another room. Mine whined and clutched at my legs with their sticky fingers whenever I talked on the telephone. And when my husband came home from work, he usually drifted into the kitchen to lift a pot lid to peek at that night's supper before stretching out on the couch for a few minutes. The soap opera hunk floated into his living room midafternoon and carried his lady off to the bedroom where he spent hours making love to her amid rose petals and candlelight!

These programs did nothing for my marriage. Instead, they created unrealistic expectations about male/female relationships in my young, impressionable mind. Talk about the young and the restless. After a few of these programs I became just that. There was no way my poor husband could have matched those perfect men who graced my television set Monday through Friday. Intellectually, I didn't expect him to be like them. But somewhere in my imagination unhealthy seeds were planted. Once there, they sprouted into full-blown discontentment. My

unsuspecting, hard-working husband never knew that these daytime icons were wreaking havoc on our home. But in time I knew it. I went cold turkey, saying good-bye to the glitz and glamour of the soap opera world. I've never looked back, and my marriage is the benefactor of this decision.

Husbands can be a lot of things, but they can't be our everything. They are companions, lovers, confidants, partners, and pals. But they can't be perfect. They aren't mind readers. They aren't our fathers. Your husband is not your savior or even your therapist. He is not your road to happiness or your ticket to self-worth. He can't think like a woman. And he is not you. Expecting him to be these things is unfair. You will be disappointed, and he will be frustrated.

Take time to get to know your husband — his thoughts, his goals, his dreams. Don't buy into the notion that you can change him or mold him to be what you want or think you need. He is his very own, unique person, and his personality has undoubtedly been set for a long time. You won't be able to recreate him. The only one you have the power to change is you. You wouldn't want your husband to spend his married life trying to change who you are. And he doesn't want to be remade by you either.

Be content with the man you married. Discontentment breeds a load of unhappiness for you both. As Hebrews 13:4-5 warns, the grass is greener syndrome leads to greed and lust, possibly creating desire for a man other than your husband. If you want to find happiness with a man, work on the relationship with the one you have at home. In reality we are one choice away from hurting a lot of people and damaging valuable relationships. If I become discontented in my marriage and look at other men to make me feel appreciated, I could fall into the trap of an affair. That would hurt my husband, my

children, our parents, the other man's family, my friend-
ships, and ultimately my spiritual self. Contentment is
worth achieving when you realize the far-reaching ramifi-
cations of discontentment.

Fortunately, we aren't called to make many lifetime
commitments. It's a good thing, too, because lasting rela-
tionships require hard work. We are often told that rela-
tionships only work if each person is giving 50 percent.
Truthfully, though, the best marriages are made when
each person is giving 100 percent to the relationship. A
smiling bride in a wedding photo can continue to smile
when she decides to heavily invest in God and commit to
loving her husband, just as he is, for the rest of his life.

Reflecting on My Face as a Wife

Genesis 2:18-24

How close are a man and his wife supposed to be?

What are some things that could stand in the way of this bond?

2 Corinthians 6:14-15

How does this principle apply to marriage?

What problems could arise from a Christian marrying a non-Christian?

What are the rewards of two Christians marrying each other?

Ecclesiastes 4:9-12

God designed marriage for two people to share. Why are two better than one?

What are the three strands of a strong marriage cord?

Proverbs 31:10-31

In what ways does this woman demonstrate unselfishness?

What blessings do you think she enjoys because of her attitude?

Matthew 18:21-22

How easy would it be for you to forgive your husband this many times?

What are the sins you have a hard time forgiving? What will it take for you to forgive and forget these things?

Are your expectations of your husband realistic?

Can you forgive him for any inability to meet your needs?

1 Corinthians 13:4-7

Substitute your name for the words "love" and "it" in this passage. Read the verses aloud for a lesson in humility.

Which phrases were easy to read and which were hard?

Which areas do you need to commit to God and work on?

Hearts Full of Treasures

⚜6⚜

There are three words that strike terror in the heart of every Christian woman: Vacation Bible School. This week-long event requires the strength of Samson, the patience of Job, the diligence of Moses, the courage of David and the energy of Paul — all wrapped up inside each VBS volunteer.

I like teaching Vacation Bible School, but it is tiring. One year our minister got the idea to scour a designated housing area teeming with kids in search of VBS students. So many children wanted to attend that our church van shuttled kids in several back-to-back shifts each morning. Excited children, who would have otherwise spent the day alone while their parents worked, were dropped off in gaggles at the church building door. Eighteen of them — two with special needs — were deposited into my fourth-grade classroom. I prayed I was up to the task.

The week was filled with Bible stories, songs, crafts, snacks and new friendships. Time was spent each day preparing for the best part of VBS, the Friday evening program. I told my students that the program would be a time for their parents to visit and see what we had been doing all week. The theme that year revolved around Psalm 23. My class decided to dress in costume and act out David's psalm. Everyone had a part and all were eager to perform — especially Elizabeth.

Elizabeth was a shy girl with shoulder-length, ash blonde hair and large blue eyes. All week she devoured the stories of King David, stories she was hearing for the first time. Being raised by a single mother, Elizabeth was excited to share with her mother all she had learned at VBS. She wanted her mother to see the picture she painted of fluffy, grazing sheep, with cotton balls glued in the center of their bodies.

She was eager for her mother to see her act out the part of a well-tended sheep in our play. Most of all, she wanted her mother to meet me.

"She will like you," Elizabeth told me Friday morning before she left for home that day. "And I like you," she added.

"I like you, too, Elizabeth," I said as I hugged her. "I am looking forward to meeting your mother."

Elizabeth smiled and headed for the church van. But she wasn't smiling that night when she returned for the VBS program.

"What's wrong?" I asked the sullen girl.

"My mom couldn't come," Elizabeth said in a quiet voice. I could tell she was trying hard to dam up the tears that threatened to flood her face at any moment. "She said she had to work."

A memory from my own childhood flashed through my mind. When I was a kindergartner back in the early 1960's, it was a tradition in my class for each student's mother to come to school on the day of her child's birthday and bring treats for the entire class. In those days the vast majority of mothers stayed at home to raise their children. A tiny minority worked outside the home. I couldn't remember a single child being disappointed by a mother not showing up with a tray full of cookies or a box of cupcakes.

But when my May birthday rolled around, my mother broke some devastating news to me. She would not be coming to school for my special day because she couldn't leave work to do so. Since my parents' divorce and my father's sudden departure from the state, my mom was forced to enter the work world as a bookkeeper. She needed to provide for her three young daughters. She could not afford to take time away from her job to deliver birthday treats to my school. I tried to understand, but it was hard to hide my disappointment. I would be the only kindergarten student that year who would not have a classroom party or introduce her mother to the class.

I was anxious for school to end that day. I hoped no one would guess it was my birthday and ask why there were no treats. A few minutes before the school session was about to end, my teacher suddenly called to me from the front of the classroom. "Vickie, there is someone here to help you celebrate your birthday today."

I looked toward the door. In stepped my grandmother, my great-aunt and my great-grandmother. They carried a beautifully decorated birthday cake, napkins, cups and Kool-aid. It was a true act of love and I shall never forget them for it. Even though I wished my mother could have been there, no one in my class ever had three relatives show up with birthday treats!

"It will be alright," I told Elizabeth just before the program began. I hoped one of her relatives would show up to take her mother's place. If it had worked for me, I

figured Elizabeth would be heartened to have anyone show up to watch her perform.

But as the time neared for my class to take the stage, Elizabeth checked the audience over her shoulder. I could tell from her disappointed expression that no one had come. She leaned over to me as the class before us was receiving their applause and preparing to leave the platform.

"I have something to ask you," she confessed. "I know it would not be for real, but since my mother couldn't come, could you pretend — just for tonight — to be my mother and clap real hard for me?"

My heart shattered into a hundred pieces for this little girl. She had only known me for five days. Yet it was so important for her to be valued and loved that Elizabeth was willing to allow me, an almost stranger, to sit in for her most important earthly relationship.

"I would be honored," I managed to say, the words strangling in my throat. And for that one night, I, the Vacation Bible School teacher, played the role of mom for another woman's child.

Undoubtedly the best known mother is Mary, the woman God chose to be the mother of His Son Jesus. For centuries Bible scholars have discussed Gabriel's angelic message of impending motherhood, the immaculate conception, the virgin birth and Mary's willingness to overcome fear and public ridicule to serve God. Maybe because they are men, few writers speculate about the challenges of being the Savior's mother. I have often thought about Mary while watching my own children grow from babies to young adults. Although she wasn't perfect, I have come to admire and respect Mary a great deal for her strength and dedication.

Two times the Bible says Mary treasured an aspect of Jesus' life in her heart. Storing up memories of their children is normal for most mothers. So what was significant about these two incidents that Mary found so treasurable? First there was her baby's birth. Mary, a virgin pledged to a man named Joseph, was startled one day when an angel of God called her name. The angel, Gabriel, informed the

young woman that she would soon be pregnant by the Holy Spirit and give birth to the Son of God (Luke 1:26-38). Although this news must have been shocking, even scary, Mary agreed to trust God and carry out His mission.

The first thing she did was hurry off to tell her relative, Elizabeth, the amazing news. I would guess she needed to confirm her sanity with another woman, whom Gabriel also claimed to have visited. Elizabeth and her husband Zechariah were old — well past child-bearing age. Even though they had longed for a child to love, no baby arrived. Part of Gabriel's message to Mary was that Elizabeth was pregnant, despite her gray hair and wrinkled face.

> When Elizabeth heard Mary's greeting, the baby leaped in her womb, and Elizabeth was filled with the Holy Spirit. In a loud voice she exclaimed: "Blessed are you among women, and blessed is the child you will bear! But why am I so favored, that the mother of my Lord should come to me? As soon as the sound of your greeting reached my ears, the baby in my womb leaped for joy. Blessed is she who has believed that what the Lord has said to her will be accomplished!" (Luke 1:41-45)

I'm sure this was all the confirmation Mary needed to believe Gabriel's visit was no hallucination.

When the time came for Mary's baby to be born, Caesar Augustus decreed that a census would be taken of the entire Roman world. Everyone was required to venture back to his hometown to be counted. Even though Mary was soon to give birth, she and Joseph traveled three days to Bethlehem, the town of Joseph's descendants. This could not have been an easy journey for a pregnant woman. Bible storybooks picture Mary serenely seated atop a donkey. I know from experience that going over road bumps in a car can be uncomfortable while

pregnant. I can't imagine being nine months pregnant and bouncing up and down on the back of a donkey for three days. And if there was no donkey, Mary would have walked three days worth of miles. Walking even a couple of blocks is tiring for a woman about to give birth!

Mary and Joseph finally arrived in town, exhausted from their travels. Since so many others had also traveled to Bethlehem for the census, the young couple could not find a spare room. They were allowed a space out back with the animals. It was there that Mary experienced the pains of labor and the strain of childbirth. And when her first baby was born, she wrapped him in strips of cloth and gently laid him in a manger, a wooden trough used to hold animal feed. There was no fully-equipped hospital, no team of attending nurses, no warming lights and no paper diapers or soft, cuddly baby clothes for Mary's tiny son. The smell of hay and donkeys, the cool night breeze, and a committee of mystified shepherds were all that greeted Jesus as he entered this world (Luke 2:1-20).

"But Mary treasured up all these things and pondered them in her heart" (Luke 2:19). This statement is not hard for mothers to understand. Give her the chance, and any new mother will gladly give a play-by-play description of her childbirth experience. She will wear the number of hours she spent in labor like a badge of courage. She will describe in detail the varicose veins, the backaches, the stretch marks, the doctor visits, her stay in the hospital. Her eyes will fill up as she recalls her husband in the delivery room, hearing her baby's first cry, and seeing her child's little, red face for the first time. Every birth is a miracle from God, and all mothers ponder this great treasure in their hearts.

It's Mary's second account of treasuring that requires more thought. When Jesus was twelve years old, his family

went to Jerusalem for the Feast of the Passover according to Jewish custom. On the return trip Mary and Joseph suddenly realized they had been traveling an entire day and had not seen Jesus. They searched the mob of relatives and neighbors but could not find their son anywhere. Retracing their steps to Jerusalem, they anxiously looked for the boy. After three days of desperate searching they finally found Jesus, a pre-teenager, sitting in the temple courts among the teachers of the law. The teachers were intently listening and were even asking questions.

"Everyone who heard him was amazed at his understanding and his answers," the Bible states in Luke 2:47. Since Jesus' conception and birth Mary and Joseph had known this would be no ordinary child. Still, they were "astonished" to find him instructing these great leaders of the temple.

"Son, why have you treated us like this?" Mary asked him. "Your father and I have been anxiously searching for you" (Luke 2:48).

I can imagine Mary's emotions. My toddler son got lost in a discount store once. I was frantic with worry. Mental images of kidnappers or my baby wandering around in the parking lot terrified me. Finally, an announcement over the store's intercom informed me that my son had been found. He was waiting for me at the customer service desk. My ordeal lasted only a few minutes. Mary must have been racked with fear not knowing where her son was for three whole days.

When my little boy Dru and I were reunited, he ran up and hugged me tightly with his chubby two-year-old arms. Mary's son reacted much differently to his parents. "'Why were you searching for me?' he asked. 'Didn't you know I had to be in my Father's house?'" Can't you just picture Joseph scratching his head, perplexed by such a

remark? Jesus was basically telling Mary and Joseph he did not belong to them but was sent to fulfill God's purposes. He was reminding them that even though they were his earthly parents, chosen by God to raise him, he had another Father and needed to be about His business. This must have been quite a jolt to Mary and Joseph. The Bible says they did not understand what he was saying.

"But his mother treasured all these things in her heart" (Luke 2:51). You see, we moms can quickly recall the times our kids got lost, said or did something funny, learned a new skill, earned an honor roll bumper sticker or hit a home run. We record such events in the baby book and in letters to Grandma. We treasure these memories in our hearts. Mary was just like us.

Every child is a treasure from God. Each is priceless, rare, precious and unique. Worthless treasure is an oxymoron. God does not give valueless gifts. A treasure does not have to be perfect to be valuable. A diamond tiara still has monumental worth even if a couple of the diamonds are missing or its base is cracked. The same should be said of our children. They don't need superior intelligence, Miss America looks, exceptional manners, impeccable behavior and a flawlessly formed body to be worthy of treasuring. All children with their unique gifts and limitations are equally valuable.

Ask the parents of a mentally disabled child what she has brought into their lives. You will hear memorable stories of blessings and joy. There is a boy in my son's baseball league who takes the pitcher's mound each year without real legs. When he gets a hit and struggles on artificial limbs to make it to first base, he touches the soul of everyone at the ball park. This child is a blessing to each player, coach, umpire, and fan who encounters his inspirational spirit. He is his parents' treasure.

Likewise, don't tell Donna her son wasn't valuable. In the days after his birth, it became evident he would never see, hear, speak, think in depth, crawl, walk or even sit up. This baby has gone on now to be with God, but Donna will never stop loving and treasuring him in her heart.

When Cindy, another young mother, was five months pregnant, she was told to abort her imperfectly developing baby. Her precious unborn child had anencephalia, meaning most of his brain was missing. "It is bad enough to know my baby is going to die," Cindy told me after hearing this devastating news. "But now my doctor wants me to pick the date and time of his death." A strong Christian woman, Cindy carried her baby to term and gave birth to her son, Samuel. She lovingly cared for him at home, feeding him formula through a tube she had to insert down his tiny throat several times a day. Samuel did not have the brain capacity to suck or even to cry. Yet, his mother held him, sang and talked to him, and four months later, cradled him in her arms as he died. There is no one strong enough to pry Samuel's memory away from Cindy's heart — ever.

Your child is a priceless treasure even if she can't sing a note, can't dance a step, doesn't make all A's, didn't earn the badge, made second string, forgot her lines, repeated third grade, missed the last shot, dropped the pop fly and finished in last place. Our kids aren't valuable for what they do or achieve or for being perfect. They are valuable just because. Just because they are who they are. Just because they are entrusted to us by God. From the beginning of her child's existence, a mother's heart becomes a treasure chest full of her children. No thief or even the passing of time can permeate it.

If you are a mother, do your children believe they are treasures? There are many practical ways mothers can let

their children know how much they are valued. Words of affirmation, notes tucked into lunch boxes and daily expressions of affection are good for starters. No matter how primitive, hang your child's artwork on the refrigerator or in frames on the walls. Attend their concerts, plays, games and school conferences. Play games together. Read books aloud even after the kids are old enough to read to themselves. Talk every day about their concerns and triumphs. "Date" your older children. If these things don't come naturally to you, find an older woman to mentor you. Titus 2 tells us that older women are to teach younger women to love their children. As stated in a previous chapter, love as an emotion comes fairly easily to most women. Unconditional love and devoted love aren't always simple to muster and need to be learned.

To maintain their shine, treasures must be cared for regularly. Treasures are always valuable, but sometimes great worth gets hidden under layers of tarnish and dust. Obviously, children need to have their physical needs met. Likewise, they must be maintained emotionally through affection and praise. Valuing your children also means disciplining (training) them. Proverbs 29:15b warns that a child left to himself will disgrace his mother. Children need loving correction, training, responsibility, and accountability. We do them no favor if we neglect our treasures in the area of training. Unruly children turn into rebellious adults. Trouble will follow if they don't learn the benefits of discipline. An adult is much better equipped to be self-disciplined if his parents have trained him from childhood. Part of a parent's job is to raise a child toward successful independence. This cannot be accomplished without training the child to be responsible.

Much as a treasure gets tarnished without proper attention, it can also become lost through neglect. Think

of buried or sunken treasure. The owner didn't mean to lose her prize, but she failed to guard it carefully. We get one chance to raise our children. They cannot raise themselves, otherwise God wouldn't have invented parents. It is a parent's duty and privilege to see her child from babyhood on to adulthood. If we neglect to care for our children, they remain treasures, but their worth may be hidden from the world. Parents must tend their treasures, regularly polishing them and reminding them of their great worth. If a treasure is treated as valuable, it will act valuable. Neglect it and your treasure will become buried in insecurity and self-loathing. A neglected and lost treasure will eventually create an empty spot in the mother's treasure chest — her heart. For every person in prison or drug addicted on the streets, there is a mother with a heart of pain.

Stand by your children in tough times, but don't rescue them. Sometimes the best lessons are learned through struggle. Consider the oyster. A tiny grain of sand settles inside the oyster shell, rubbing and irritating the creature inside. Through a long, painful process, the little grain of sand changes into a beautiful pearl, a gem of great worth. If a mollusk mom continually brushes the grain of sand out of her child's shell each time one settles there, that oyster will never achieve its natural potential. No pearl will form.

We, too, must guard against rescuing our children. It is often said not to get between a mother bear and her cub. Well, watch out if you come between a mother human and her child, too! A good mother's first instinct is to protect her child from anything harmful. A close friend once advised me to stop praying away all bad things from my children. "How do you know you aren't asking to have removed the very thing that God could use to

bring your child closer to Him?" I don't, so I stopped — well . . . for the most part. Now instead of praying for God to keep all harmful things away from my children, I ask that He protect them as He teaches them valuable lessons through the hard knocks of life.

No mother likes to see her child struggle or suffer. We naturally want to rush in and fix the problem. Sometimes this is necessary. But sometimes a child learns more if she has to search for a solution, do a little problem solving and risk taking action on her own. Mom can guide, listen, and offer compassion and advice, but her child will grow more if she doesn't rescue him from every uncomfortable situation. Consequence is a good teacher. If your child is in the process of growing from a grain of sand into a lustrous pearl, pray for her and with her. Console and comfort her and help her sort out the options. But don't rob her of a growth experience. When she comes face to face with her own problem, seeks out her own solution and puts her plan into action, the way she looks at herself will improve. Your little treasure will sparkle.

At times, even if you are the best mom in the world, your kids will still run into problems. They have free will. You can't follow them around all day as they go to school or out with friends. Sometimes your children will make bad choices. Your treasure can sink in despair if you turn your back when he needs your support. Even smart kids do dumb things. It's part of growing up. I'm not talking about bailing him out. Instead, hold him accountable for his mistakes and help him develop a plan of repentance, restitution and restoration.

There was a group of high school seniors who came from prominent families in our town. These were smart kids who did a stupid thing. The week before graduation these kids built homemade bombs and placed them in

mailboxes around town. Fortunately no one was hurt. However, such a crime is a federal offense, and these kids found themselves in deep legal trouble. As affluent individuals, their parents could have pulled a few strings to lessen their children's charges. They could have paid the fines and lawyer fees and asked the newspaper not to print the humiliating story. Instead, these moms and dads held their children accountable for their decision to break the law. The kids worked to pay the fines and fees and they faced the judge themselves in court. They also missed graduation. The price was high, but these children learned and grew from a bad experience. Had their parents rescued them, they wouldn't have learned a thing.

We often have the misconceived notion that raising the Son of God must have been a piece of cake. Being God, Jesus would have been perfect. How hard could it be raising a perfect child? But in the book of Mark, we learn even Mary experienced pain brought about by Jesus' choices. Word reached Mary that Jesus was so busy preaching and so pressured by massive crowds that he sometimes went without eating. She also heard that the Jerusalem teachers of the law (possibly those Jesus dazzled twenty years earlier with his great wisdom) were talking maliciously about her son. They were even calling him Beelzebub, or Satan (Mark 3:20-22). Knowing her son was being condemned and going hungry caused Mary to react like most mothers. She went to "take charge of him," believing him to be "out of his mind."

So Mary and his brothers went to the place where Jesus was preaching. A large crowd gathered both inside and outside the house. So large, in fact, that Mary couldn't make her way in to see her son. Instead, she had to send word through the crowd to him. Mark 3:32-35 describes :

"Your mother and brothers are outside looking for you."

"Who are my mother and my brothers?" he asked.

Then he looked at those seated in a circle around him and said, "Here are my mother and my brothers! Whoever does God's will is my brother and sister and mother."

Mary had come to rescue her son from hunger pangs and accusers. But Jesus didn't want that kind of help from his mother. In words that surely stung her ears and pierced her heart, Jesus likened anyone who wanted to serve God to his mother and his siblings. I can picture her face as she heard his words, turned away from the crowd, and walked home not knowing how the next town would treat her beloved firstborn. Jesus was not being cruel or unloving to his mother. He had a mission to fulfill and could not be sidetracked even by his most important relationships. This memory had to be a painful treasure stored in Mary's heart.

We can't stand in the way of God's purpose for our children. They belong to Him first. We must train them to seek Him before all other earthly relationships or material possessions. God expects you to train your treasures to shine spiritually. They are to become salt and light to the world. To do that we must be like Mary and learn to let go. Our children must go on to babysitters, kindergarten, college, a spouse, a move, and their own choices in life. As much as we mothers would like to, we can't go with them. Mary couldn't, and neither can we.

Sometimes physical treasures are taken by thieves or fire or donated to a museum for many others to enjoy. Our treasured children can be claimed by disease, accident, or death. They can also become a blessing or an example to many others. We can fight against this plan. We can question God when He singles our children out for a higher cause. Or we can learn from Mary in this area, too.

When Jesus was born in that drafty stable, I wonder if Mary kissed his soft, downy head knowing it would some day be bloodied by a cruel crown of thorns. Did she caress the smooth skin of his infant body knowing her son would be spit on and whipped again and again, shredding his back like raw meat? When she looked into his newborn eyes, did she already see signs of pain for being misunderstood? When he gripped her finger with his tiny hand, did she carefully trace the spots where the spikes would be driven some 33 years later? As she wrapped him in those strips of cloth, did she know that wicked soldiers would gamble for his last piece of clothing, a tunic she lovingly stitched as his gift of independence when he left home? And when he cried to be fed that night, did she have a vision of his final breathless words as he hung naked and dying on the cross?

Mary knew the pain of letting go. Though it wasn't easy to overhear people describe her son as a lunatic or see him unfairly tried as a criminal, she knew he was his Father's son first. God had a plan in all that pain. I pray that none of us mothers today will have to see our children crucified. But our modern world does not lack physical pain, even when it comes to children. There is nothing more painful than watching a critically sick child struggle for life or losing a child through death. One modern-day Mary related this to me soon after being told her little girl had leukemia:

> When your five-year-old child is diagnosed with cancer, it is the ultimate feeling of powerlessness. Our family's lives were changed forever when the doctors told us it was leukemia. We watched them aspirate bone marrow from our precious baby's tiny, little hip. She slept through it. Her daddy sang softly to her as his tears dripped onto her cheeks. I held onto him and cried hysterically. The nurses and doctors all had tears, too. Chemotherapy was started

and surgery was performed to implant a port-a-catheter device in her chest for receiving chemo, drawing blood — anything intravenous. She gets her medicine orally, intramuscularly (shots in her legs), intraveneously and in her little spinal column. She is now bald and will have to endure great pain, sickness and suffering to buy time here on earth. It is so hard.

Jan is still trying to piece her heart back together after her treasured teenage son was tragically killed in a car accident. She struggles to see purpose through pain. She and her husband donated their son's organs, giving precious life to others. Peter's funeral was carefully detailed to minister to his grieving friends. His parents gave the memorial contributions to a community baseball league their athletically gifted son had enjoyed. Now Jan is writing a book, praying to give other grieving parents hope and courage. While all of her acts turn pain into purpose, Jan misses her son terribly and wishes with all of her heart that she could have him back. Through her faith she goes on, though it is not an easy path. "I told God it hurts too much to lose a son," Jan told me one day. "I felt Him say to me 'I know, I gave you mine.'"

Only God knows the plans He has for our children or how rocky their road is going to be. Only He knows their departure time from this world. If it is God's will, we must let go of our children so that others can benefit from their lives — even if letting go means buying a casket and a cemetery plot. God blessed you with a certain amount of time to share with your treasured child. It is not without purpose. Jeremiah 29:11 tells us God has plans for all of us including our children. If God seems silent in your times of suffering over a child, ask Him to reveal His purpose to you. Remember, God is always with you every step of the way. He knows your hurt; He feels your pain.

Take a lesson from Mary who often had to love her son from a distance. She stood at the foot of a cruel cross for one last chance to love her son up close. Although it surely was excruciatingly painful, she wouldn't have wanted to be anywhere else at the time. If God brings you to your child's hospital bed or asks you to linger beside your baby's casket, He will hold you in His arms and bless you for your courage and faith.

For All Parents

I'll lend you for a little time, a child of mine, He said.
For you to love while he lives, and mourn when he is dead.
It may be six or seven years, or twenty-two or three,
But will you, till I call him back, take care of him for me?

He'll bring his charms to gladden you, and shall his stay be brief,
You'll have his lovely memories as solace for your grief.
I cannot promise he will stay, since all from earth return,
But there are lessons taught down there I want this child to learn.

I've looked the wide world over in my search for teachers true,
And from the throngs that crowd life's lanes, I have selected you.
Now will you give him all your love, nor think the labor vain,
Nor hate me when I come to call, to take him back again?

I fancied that I heard them say, "Dear Lord, Thy will be done.
For all the joy Thy child shall bring, the risk of grief we'll run.
We'll shelter him with tenderness, we'll love him while we may;
And for the happiness we've known, will ever grateful stay.
But shall the angels call for him much sooner than we planned,
We'll brave the bitter grief that comes, and try to understand."

— Edgar A. Guest

There may be times when we as women are asked to care for another woman's treasure. Mary had been a good mother and Jesus was unselfish enough, even as he hung on the cross, to share her with another human being.

"When Jesus saw his mother there, and the disciple whom he loved standing nearby, he said to his mother, 'Dear woman, here is your son,' and to the disciple, 'Here is your mother.' From that time on, this disciple took her into his home" (John 19:26-27).

There are children all around you who need treasuring. Some are orphans. Others suffer from inadequate parenting, abuse or neglect. There are many ways to mother other people's children: adoption, foster parenting, representing a child in court, volunteering in a juvenile detention center, watching out for the neighbor kids, babysitting for relatives, coaching a team, leading a Scout troop or 4-H club, or teaching Sunday morning Bible class.

One of the saddest days of my life was spent visiting my niece in a drug rehabilitation center for teenagers. Each child was to be represented that day by a parent or other relative for family group therapy. Tragically, many of these kids did not have an emotionally healthy relative to fill the bill. They were left to fight the grips of addiction without the support of even one loving, adult, family member. They were treasures locked away to tarnish and rot. This should not be. A caring adult volunteer would have meant the difference between desperation and hope. A woman willing to fill a mother-shaped void inside a neglected, hurting child could turn sadness into joy, hopelessness into a future.

Our world is starving for caring, loving, mother figures to speak out for children. Lonely kids need to be touched and heard. They need someone to invest time into their lives. They need a vision for what they can become. If you know a child who is not being treasured by her parents, see what you can do to be a blessing in her life. Think of the societal difference it would make and

the impact on God's kingdom if every Christian woman took the time to love one other child in addition to her own!

Finally, let me speak about grandmothers. Proverbs 17:6 says children's children are a crown. If your children are pearls and diamonds, then your grandchildren are an entire crown of treasures. If you are a grandmother, you are a "grand" mother — a mother of all mothers. Grandmothers are invaluable when it comes to taking proper care of little treasures. They can build incredible memories in their grandkids and pass on a heritage of love. They can also impart a legacy of spiritual faith like Lois did for her daughter, Eunice, and her grandson, Timothy. (2 Tim. 1:5) Imagine Lois's joy when Timothy grew to become an evangelist who passed on her teaching to many others.

The time I spent with my grandmother and my great-grandmother forever impacted my life. Their unconditional love and complete acceptance helped me overcome many obstacles. I urge all grandmothers to continue their mothering in a grand way. Even if your grandchildren live far away, do everything you can to build a relationship with them. It will take time and a little creativity, but the return in your grandtreasures' lives will be well worth the effort.

God is so smart. His design calls for the unborn child to develop inside a woman, directly under her heart. There is something special about a mother's heart. An invention that simulates a heartbeat has been marketed to new parents. It is said to lull a fretful baby to sleep, reminding him of the warm, safe environment he first knew as Mom. It is, therefore, only fitting that a child remain forever fixed in his mother's heart like a chest of treasures stored there by God. And long after the child leaves his mother's care, a treasure chest of memories is left behind. Not only is God smart, He is generous.

Reflecting on My Face as a Mother

How do you let your children know they are treasures?

In what ways do you now relate to Mary?

Proverbs 20:11

How important is it to train your children?

What can happen if you neglect to do this?

1 Chronicles 29:3-5

Just as David gave his personal treasures as a devotion to God, how can you devote the treasure of your children to God?

Do you trust God to use your children's bad choices to teach them spiritual lessons?

Matthew 6:19-21

How does this correspond to children?

In what ways are you making sure your child is a heavenly treasure?

Psalm 78:5-8

What charge does God give to parents and grandparents?

If this plan is followed, what will be the end results?

Luke 12:34

How far will your child have to travel to totally escape your love?

My Sisters and Me

⚍✛7✛⚎

Josie had her parents all to herself for seven years. Then Wilma Jean was born. At first, having a baby sister in the house was like playing with a real life baby doll. Josie proudly introduced "her baby" to those who came to visit. As the years went by and Wilma Jean grew from a baby to a curious toddler, Josie learned to keep her prized possessions far from her little sister's reach. And by age 12, Josie had a permanent shadow in the shape of her kindergarten sis. Since their mother worked a factory job each day, Josie was required to watch Wilma Jean in the summers, greatly curtailing Josie's growing fascination with boys and a desire to be with her friends.

"Watch out for your little sister," Josie heard so many times that she felt like screaming.

One day while their mother was away at work, Josie grew weary of her constant tagalong. Leaving five-year-old Wilma Jean home alone, Josie headed for the neighborhood swimming pool with her girlfriends. She would only be gone for a couple of hours, she rationalized. Surely Wilma Jean could entertain herself that long.

When a slightly sunburned Josie returned that afternoon, she found her little sister sitting in the middle of their parent's bed, their mother's jewelry strung out all around her in little heaps. Earrings had rolled under the bed. Necklaces were tangled in knots. Assorted jewelry dangled from Wilma Jean's arms and neck.

"What are you doing?" Josie demanded.

"I'm playing dress-up," Wilma Jean gleefully explained, clip-on earrings twinkling from her tiny earlobes.

"Well, take that stuff off and put it away before Mom gets back," Josie ordered. "You know she doesn't like us getting into her things."

Wilma Jean knew her big sister was right. When their mother was at work, her bedroom was strictly off limits to the girls. Wilma Jean tried cramming the jewelry back into the jewelry box. But it didn't fit as neatly as it did before her curious hands discovered it. Knowing her mother would notice the tangled mess of beads and baubles, Josie pitched in and helped sort the pieces into the jewelry box's divider trays. It took about an hour to unravel Wilma Jean's afternoon of play and scrub their mother's best perfume off Wilma Jean's neck.

"I'm going to tell Mommy you left me here and went swimming with your friends," Wilma Jean suddenly announced as Josie was wringing out the washcloth in the bathroom.

"You wouldn't dare!" Josie was indignant. "If you do, I'll tell her you got into all her jewelry. She won't like that one bit."

"Well, I'll tell her I didn't have anything to do because you left me here all alone," Wilma Jean shot back.

Josie had been cornered by a kindergartner. She needed a quick exit out of this situation. Their mother would be home shortly.

"I'll tell you what," she said to her little sister. "If you won't tell, I'll make you some cocoa. How's that?"

Wilma Jean thought about the deal she had just been offered. She liked her sister's cocoa. Besides, she knew that Josie would get the switch if their mother found out she hadn't watched her sister that afternoon. She hated it when Josie got switched.

"Okay, but I want two cups," Wilma Jean bargained.

For years, Josie bribed her little sister with steamy cups of hot cocoa. By the time Wilma Jean was old enough to heat the stove and make her own cocoa, Josie had graduated from high school and had gotten married. The two women now laugh about the numerous cups of hot chocolate Josie concocted for Wilma Jean during their growing-up years together. Those many shared cups of cocoa served as a bond between the sisters. Cocoa got them out of scrapes with their mother. It warmed them on cold, winter days after walking home from school together, Wilma Jean's little hand in Josie's bigger one. The cocoa Josie made brought comfort to her little sister every time their alcoholic father left for days at a time and their wounded mother retreated to the solitude of her bedroom.

Today, Wilma Jean, now in her 70's, cares for Josie, who is 83. Wilma Jean makes sure her big sister takes her medicine on schedule. She gently shampoos Josie's hair in the bathroom sink, reminding her of the fun they had growing up as sisters. She sits on the edge of the bed and reads Josie letters from the grandchildren, blessing her sister's final months on earth. Wilma Jean knows that Josie's days

are getting fewer. As she purées fruit in the blender to serve with Josie's supper of mashed potatoes and yogurt, Wilma Jean wonders how she will get along without the company of her big sister. So, just for old time's sake, she makes Josie a cup of cocoa and stirs it with love.

Sisters — though they try you at times, you still gotta love 'em. Coming from the same genetic background, biological sisters are bonded by blood and heritage. If you wear the face of a sister, there is no one more like you than your sister. You may not look the same or have similar abilities, interests and personalities, but once you've shared a womb and a room, you and your sisters are cemented for life. No matter how many years or miles separate you and your sister, she will always be a part of your heart, mind and soul.

I was five years old and my sister, Nickie, was four when we first entered day care. Having been home with our mother during our early years, it was quite a shock to enroll in a large, noisy, crowded child care center. Immediately, I knew I did not want to be there. I resented that my mom now had to work, leaving my sister and me in the care of strangers.

Soon after my mother dropped us off that first day, Nickie and I were separated. She was whisked away to a playroom where other four-year-olds interacted amidst boxes of toys. I was hustled upstairs to be with other kindergarten-aged children. I sobbed hysterically and refused to play with anyone. No one could console me. I was in strange surroundings, unfamiliar faces all around me. All I wanted was to go home, which I was told was not possible. The next best thing, I mournfully decided, was to be with my sister. If I couldn't go home, then at least these workers could allow me a little piece of home in the form of my sister. I remember begging them to let

me go back downstairs where Nickie was. Seeing my unrelenting anguish and realizing I couldn't be coerced into playing with the other kids, an exasperated woman grabbed my hand and marched me downstairs.

My teary eyes scanned the room for my little sister. Seeing her in the back corner building with blocks, I rushed to her side and clung to her for dear life, wailing loudly. Nickie had almost instantly resigned herself to being in the day care center and was perplexed by my agony. She let me drape myself around her neck and continue crying for a few minutes. Then she offered me some blocks. Before long I settled down and grew accustomed to my new surroundings. The bond I shared with my sister gave me the courage and strength I needed to withstand a foreign situation that day.

What is it about sisters that completes us as women? Why do sisters have such unrivaled connection? When I was pregnant with my second daughter, Emily, my five-year-old, prayed diligently for a baby sister. She already had a little brother and loved him dearly. But brothers get dirty, play with trucks, pop the heads off Barbie dolls, and make a lot of noise. To a girl, a sister is an extension of herself and Emily was anxious to experience that. One of the proudest days of Emily's life was when her sister, Lydia, was born. In all the pictures we took at the hospital, Emily's smile spreads across her freckled face as she beams down at her newborn sister. Fifteen years later Emily is still smiling. Don't speak ill of Lydia, or you will have to contend with Emily. Don't dare forget to tell Emily when her little sister has a concert or performance. She wants to be right there to clap the loudest. These two sisters don't always see eye-to-eye, but they are closely bonded. They seem to feel each other's pain and experience each other's joys.

Physical sisters are a blessing, and so are spiritual ones. In Matthew 19:29, Jesus says, "And everyone who has left houses or brothers or sisters or father or mother or children or fields for my sake will receive a hundred times as much and will inherit eternal life." Knowing the importance God places on family, I don't believe Jesus calls us to reject our family members in order to follow him. Instead he asks us to put him first (Matt. 6:33), and in doing so we will receive blessings too numerous to count (Luke 6:38). One of those blessings is spiritual family. By committing to Christ as your primary relationship — ahead of mother or father or sister, God will give you many, many spiritual mothers, fathers and sisters. If one biological sister is special, think how great it will be to have a hundred spiritual sisters!

Like my daughter Emily, Christian women should dream and pray about future sisters in Christ. Each time you meet a woman, envision her through God's eyes. We know God wants all people to be saved and come to a knowledge of the truth (1 Tim. 2:4). By sharing the gospel with other women you are helping birth more sisters into the family of God. Emily prayed for a baby sister. Do you pray for new spiritual sisters? God answers prayers — just ask my daughter. He wants us to share in His ministry, entrusting us with His message. Making new spiritual sisters is a privilege and a responsibility. It brings great joy to teach the message to other women and petition God on their behalf. The end result will be the blessing of many new sisters in your church family.

My daughters defend each other through thick and thin. It hurts one sister to hear someone criticize the other. If one gets slighted, the other labors on her sister's behalf to correct the wrong. On occasion each has even tried to convince their dad and me to withhold discipline

from her sister. It would be wonderful if we felt this way about our spiritual sisters. Churches would experience tremendous unity if sisters would give each other the benefit of the doubt and refuse to criticize or gossip about one another. Our spiritual bonds would become strongholds if we stopped tolerating the needless wounding of our sisters.

The apostle Paul knew the benefits of sisters getting along and the disastrous results when they don't. Tryphena and Tryphosa, undoubtedly twin sisters, accomplished much because they were unified in their ministry endeavors. "Greet Tryphena and Tryphosa, those women who work hard in the Lord," Paul wrote in closing the book of Romans. He commended these sisters for working hard together, bringing glory to God. He acknowledged his appreciation for their efforts by including them in his personal greeting. He held them up to other Christians as examples of a spiritually unified front.

Paul wished the same for Euodia and Syntyche, two women who were at odds. Their disagreement was so well known that Paul addressed concerns about them in a letter to the Philippians.

> I plead with Euodia and I plead with Syntyche to agree with each other in the Lord. Yes, and I ask you, loyal yokefellow, help these women who have contended at my side in the cause of the gospel, along with Clement and the rest of my fellow workers, whose names are in the book of life (Phil. 4:2-3).

Although Paul wrote the book of Philippians from prison, his entire message was one of peace and joy. In fact, the word "joy" appears 16 times in this single letter. Yet there in the middle of all that joy was an admonition to two women who had built a prison in their hearts. Bad attitudes robbed them of freedom in Christ and bound

them in the shackles of dissension. Pettiness chains. Hostility among sisters locks them in bondage. How embarrassing it must have been for Euodia and Syntyche to have Paul's admonition for peace between them read aloud to the church. These ladies surely squirmed a little in their pews, which was probably the response Paul was after. By making them uncomfortable about their disagreement Paul wanted to cause these sisters to seek compromise, peace and unity.

No two sisters see everything the same. Inevitably they will disagree on some matters. But fighting is not acceptable. Disputes should be settled quickly. Satan wins when spiritual sisters quarrel. If there is fighting within a congregation, the members' energy stays focused inside the church building. If everyone is busy ironing out internal differences, the outside, unsaved world gets neglected. The poor go unnoticed, the hungry remain unfed and the unbelieving stay unbelieving.

Notice Paul's cleverly chosen words to Euodia and Syntyche concerning their argument. He pleads with them to agree with each other "in the Lord." Paul reminds these sisters of their common bond in Christ. Unable to raise four young girls alone after her husband left the family, Jane gave up her newborn baby daughter for adoption. When her oldest daughter Susan was 35 years-old, she met her baby sister Lisa, then 30, for the first time. In most respects they were total strangers, but the women shared a bond of blood and parentage. Because of that connection they instantly found things to talk about and thoughts to exchange. Paul wanted Euodia and Syntyche to get along because of their spiritual bond through the blood of Christ. Being "in the Lord" gives all Christians an even playing field and a reason to cooperate.

Paul also challenges the congregation at Philippi to help Euodia and Syntyche work out their differences. By using the term "loyal yokefellow" Paul calls the church to family loyalty. Weary of their fighting, I bet many Christians would have liked to see Euodia and Syntyche switch congregations. But since Christ is the yoke between believers, Paul expected the other brothers and sisters to mediate between these women. Their relationship was worth salvaging. Paul knew the church would be blessed once the problem was resolved.

In his letter Paul reminds Euodia and Syntyche of their previous good work. He states, "They contended by my side in the cause of the gospel." It must have been disappointing for Paul, stuck in prison, to learn that two dear sisters with whom he had previously teamed to spread the message of Jesus were now arguing, halting their ministry. Resolution could come by calling these women back to their God-given purpose. Paul longed to have their battle settled so they could return to the spiritual battlefield, winning souls for God again. Paul also reminds Euodia and Syntyche of fellow soldiers — "Clement and the rest of my fellow workers" — who were being affected by the sisters' struggle. Family disputes hurt the entire family, not just those feuding.

Finally, Paul tells these sisters in Christ that their "names are in the book of life." By focusing on Christ's forgiveness, salvation and God's promised eternity in heaven, Paul believed these two women would forgo the squabble and return to joyful and appreciative living in Christ. In light of salvation and eternity with God all earthly matters pale in comparison. No fight is worth risking these spiritual blessings.

My husband has seven sisters. I've tried to imagine what it must have been like sharing a bathroom with six

sisters. Did they have one giant, communal clothes closet? Did they have to share all their toys? As adults my sisters-in-law stay in touch with each other and enjoy supportive relationships. But I'm sure there was a fair amount of competition in their childhood home. With siblings comes sibling rivalry, and it must have been seven-fold among the sisters in the Hull house.

All sisters have some competitive friction between them. It is magnified if their parents perpetuate rivalry. Rachel and Leah, sisters in the book of Genesis, became rivals as a result of their father's deception. Leah, the older sister, had "weak eyes," the Bible states. I don't know if this means she had poor eyesight or if she had small eyes. Rachel, on the other hand, is described as "lovely in form and beautiful." Not seeing well might have been a blessing for Leah. It would have prevented her from realizing how pretty her younger sister was. She wouldn't have known how often men looked past her to stare at Rachel. Because of the girls' differences their dad, Laban, had a harder time finding a husband for Leah than for Rachel.

When Jacob, Laban's nephew, was ready to marry, he turned to his uncle for a bride. It was Rachel he wanted, but through Laban's dishonesty it was Leah Jacob woke up to the day after the wedding. Imagine the scene that took place in the bridal chamber prior to the wedding.

"But, Daddy, Jacob wants to marry me!" Rachel whined as her sister, Leah, dropped the heavy veil down over her face to hide her weak eyes.

"Rachel, you know the rule. You can't get married until Leah finds a husband," Laban explained. "This is the best way I know to get her married off first."

"Yeah, stop your whining," Leah snapped. "Why should you always get all the guys? This may be my only

chance. Jacob worked seven years for Father, so Father gets to decide which one of us marries first. So there!"

"It's not fair!" Rachel continued to lament. "You always favor her, Daddy! You just feel sorry for her because she's the oldest and the ugliest. I'm sick of her always getting her way!"

"I don't want to hear any more about it, Rachel," Laban said. "Leah is marrying Jacob and that is final. She is the firstborn. That's just the way things are. Now shape up and put on that bridesmaid's veil."

I doubt Rachel ever accepted her sister marrying her boyfriend. Rachel and Jacob had courted seven long years, but Leah benefited by the commitment. The only people happy that wedding day were Leah, who finally got a husband, and Laban, who followed proper protocol by marrying off his older daughter to a hard-working, diligent, young man. This deceitful act did nothing to promote a healthy sister relationship. Laban only widened the gap between his daughters. Their intense rivalry continued when Rachel also married Jacob a week later.

Over the years the two sisters constantly competed for Jacob's love and affection. Their weapons of choice in this marital battle were sex and childbearing. When Leah saw that Jacob loved Rachel more, she bore him several sons, proud that she could do so. Since her sister was barren, Leah hoped to earn Jacob's love and loyalty through her ability to have children. Not to be outdone, Rachel arranged for Bilhah, her maidservant, to sleep with Jacob so she could build a family through her. That prompted Leah to also give her maidservant, Zilpah, as a bed partner for Jacob. Rachel remained childless and Leah's fertility waned. So they fought over some mandrake plants, superstitiously thought to enhance fertility. Again they used sex as a bargaining tool. Poor Jacob didn't know

who he would be sleeping with each night — Rachel, Leah, Zilpah, or Bilhah. The sisters fought about it while Jacob was out with his flocks. Whoever won the battle that day met him by the roadside and announced, "You must sleep with me tonight" (Gen. 30:16).

We might wonder why Jacob tolerated this contest for his love. Sibling rivalry was nothing new to him; it was a heritage he knew well. He had grown up with competition between siblings. He and his twin brother, Esau, fought before they were even born (Gen. 25:22-23). As tiny infants they fought over who would be born first (Gen. 25:24-26). Each of their parents openly chose a favorite son, creating fierce competition between the boys. At their parents' urging Jacob and Esau battled over everything: their birthright, their father's blessing and even the quality of their wives.

The boys' father, Isaac, had also known family competition. His mother, Sarah, competed with her maidservant, Hagar, using their sons as ammunition in the fight for Abraham's promised blessing from God. And Jacob continued the family dysfunction by creating competition between his own sons. Sibling rivalry was perpetuated into the next generation when Jacob favored Rachel's eventual son, Joseph, over Leah's sons and both maidservants' children. Read further in Genesis to see the havoc Jacob's favoritism wreaked on all his children.

Each time we see a new generation of sibling competition, we also see familial destruction. The natural bonds between brothers and sisters are taxed when children are pitted against each other. Parents do a disservice by comparing children or favoring one over another. To foster sibling relationships, parents need to appreciate each child for his or her unique qualities and encourage each to be the best that God calls him or her to be. Children are

influenced by their parents' teaching and attitudes. They will unconsciously carry a competitive spirit to their children, creating generation after generation of unhealthy sibling relationships.

This can happen in the church as well. God created us all unique. He did not give everyone the same gifts, talents and abilities. Little would get accomplished if He had. Instead He wants each to do her part as we support the work of others. Since all Christians are on the same team, there is no room in the church for competition. God does not sponsor a contest to see who can convert the most people or who can teach the biggest Bible class. He expects us to avoid jealousy when a sister is asked to speak at a retreat or is invited to sing during a luncheon. Sisters need to share with each other and serve each other. They need to look for ways to be supportive and encouraging, provoking their sisters on to love and good works.

While attending a junior high school track meet, I watched kids strategically position themselves in intervals around the track just before the two-mile race began. This was to be the longest race of the meet and the runners would need motivation to make it around the asphalt, oval track multiple times. The starting gun sounded. Each runner sprinted a few yards and then dropped into a self-determined, steady pace. Halfway through the race, the runners began to tire. Red-faced and panting, they struggled to make it to the finish line. This was a cue to their teammates stationed around the track to jump up and down and shout words of encouragement, inspiring their friends as they lumbered by. "Go, Jenny! You can do it! You're almost there. Way to go! You're doing great!" With each phrase the stride of the runner grew stronger and her jaw set a little firmer.

Mustering every ounce of remaining energy, the runners crossed the finish line one by one. Each time, there was a coach or a teammate or a parent waiting to greet them. Some runners were hugged. Others were triumphantly thumped on the back. A few collapsed in the arms of fellow runners. Kids rallied to physically help their friends stand as they struggled to breathe normally again after the grueling race. "You made it! Way to go! I knew you could do it!" Teenaged team members praised their peers as they made their way off the track. It didn't matter if their friends won the race or lost it. In either case these kids were bonded just because they had the courage and stamina to finish.

Sisters need to inspire and cheer each other on as we each struggle to finish the Christian race. We are called to share each other's joys and carry each other's burdens. If a sister hurts, rally to her side. Encourage her with words of hope and courage. If she tires of the race, position yourself in her life and urge her to press on. She needs to hear, "You can make it! You're not alone! You're doing great! Keep running! I'm here to help you."

When a sister wins an award, has a baby, gets a promotion or serves God in a special way, her spiritual family should rejoice with her. Pat her on the back, give her a hug, throw a party in her honor, or send a card letting her know you are proud to call her Sister. And when she gets too exhausted to complete her race, help her stand long enough to cross the finish line. It's tough to finish the race of life alone. But running in step with our sisters, we can make it.

My daughters, Emily and Lydia, spent six years sharing a bedroom and a double bed. When we moved to a house with four bedrooms, each girl got her own room. On moving day my girls were excited to claim their spaces in the

new house and organize their belongings the way they wanted. But when nighttime came, they suddenly realized they would be sleeping apart for the first time in half-a-dozen years. Lydia was tucked into her pink bed in the upstairs bedroom. Emily went downstairs to her new room.

The next morning I peeked into Lydia's bedroom across the hall from mine. Her bed was empty. She wasn't in the family room watching early morning cartoons, nor was she in the kitchen getting a jump-start on breakfast. Cracking the door to Emily's bedroom, I discovered Lydia cuddled up against her big sister under the covers of the iron daybed. Emily's arm was slung over both her little sister and the white teddy bear Lydia had carried downstairs sometime in the middle of the night. After that it became a common occurrence for Emily and Lydia to invite each other to "spend the night."

Knowing my girls enjoy each other is a gift to me as their mother. Constant fighting and arguing wears a parent ragged. Affection between siblings energizes a mom or dad. A harmonious home creates a haven — a place to go for comfort, support and encouragement. Our churches should be the same. When the world wears us down, we can retreat to our church homes where loving sisters greet us with open arms and kind words. When sisters in Christ band together, much gets accomplished, many souls are won, no one leaves the church family and God is pleased with His children's behavior. Now, go call a sister!

Reflecting on My Face as a Sister

Luke 10:38-41

Which sister, Mary or Martha, do you relate to most?

What was the cause of their friction?

What do you think Martha expected Jesus to do about Mary?

How did Jesus refuse to fuel Martha's flame of contention?

John 11:1-44; 12:1-3

How were Mary and Martha different?

Why did Jesus cry? Are you able to cry over a sister's loss?

Do you think Martha was embarrassed by her sister's public display of affection for Jesus? How would you react in this situation?

1 Corinthians 3

How does God feel about competition in the church?

How can we avoid it?

1 Corinthians 12

Where do spiritual gifts come from?

How is the body of Christ (the church) like a physical body?

How much do we need each other?

Philippians 2:1-8; Colossians 3:12-15

What qualities can we strive for to eliminate wordly competition with each other?

In which areas do you need prayer support and encouragment?

If we practiced these attributes, how would the church benefit?

Just Me, Myself and I

❧ ‡8‡ ❧

Shortly after my eighteenth birthday a friend and I moved into our first apartment. I couldn't wait to have a place of my own and start a new adult life, leaving childhood far behind. Joni and I thoughtfully mapped out the aesthetics of our very own apartment. We bought matching brown and gold bedspreads, raided our mothers' kitchens for old pots and pans, and decided in advance who would be responsible for each household chore. On the big day, we eagerly unloaded boxes and set up house. We purchased a few groceries and had our first meal away from our families. That evening we strategically placed her small black and white television and my simple stereo in prominent spots in the living room and invited a few friends over to see the place we would call ours that year as college freshmen.

It didn't take very long before the luster wore off and I began to see that apartment more realistically. What started out in my mind as a magical garden of budding independence soon degenerated into a desolate patch of weeds. Being a woman who depends in part on atmosphere for disposition, moving into a windowless, basement apartment wasn't the wisest choice. From our hole down under the earth, we never knew if the sun was shining or if a thunderstorm threatened. Also the apartment's layout left a lot to be desired. The rooms weren't very well defined. For example, all that divided the bedroom from the living room was a small dressing screen. So, if one roommate had a friend over to watch a late night movie on TV, the other one couldn't go to bed.

The biggest source of boundary confusion was the kitchen/bathroom combination. In one small room sat a kitchen stove and table and chairs. But the refrigerator,

sink, and cupboards were across the hall in a separate room. Unbelievably, that second room also housed the toilet and the shower. You could literally open up all the cabinets and sit on the toilet to contemplate what to cook for supper that night. You could even wash the dishes while sitting on the toilet. (Not that we ever did that! But we could have.) I could be taking a shower while Joni rummaged in the refrigerator for a snack in the same room. Oh yes, and if you weren't careful, you might fall into the sump pump because it was inside the shower. This situation was a far cry from the homes we were both used to and I began to wonder whatever had excited us about this apartment in the first place.

One day while Joni was in class and I was in the dark, dreary apartment trying to study, depression settled over me like a dense fog. We had been in the apartment only two weeks. My eyes caught the bare concrete floor, our unmade beds, and the toilet rudely perched in the middle of the kitchen. Suddenly I couldn't take it anymore. Without even thinking about what I was doing, I jumped in my car and drove the 15 miles home to my mother. She was in the kitchen cooking when I burst through the door. She took one look at my face and knew there was a problem.

"What's wrong?" she asked.

"It's that awful apartment!" I cried. "Why did I ever think I could live there?

"Plus that," I continued in wails, "I'm sick of bologna sandwiches. Why didn't I ever learn to cook? I can't do all of this!"

Some mothers would have insisted I give up this silly notion of independence at only 18 and move back home immediately so they could continue to take care of me. But my mom knew it was important for me to grow up. Even baby birds don't make it very far when they try out their wings for the first time. But that doesn't mean the mother bird lets them slop around in the nest forever. I needed to grow up, move on and build a life away from my mother's watchful eye. Instead of holding me back, Mom listened to my woes, fed me a hot meal, packed the leftovers in a box, and followed me back to the apartment. She inspected the basement from room to room and suggested improvements. She even purchased a box of floor tiles, and on her hands and knees, installed a new floor so we wouldn't have to walk around on cold, hard concrete any more. Of course, there was nothing she could do about the toilet situation, but hearing her laugh about it helped put our kitchen/bathroom combo in perspective.

By showing me how to make the best of an imperfect situation, my mother taught me to accept what comes along. This set the stage for contentment in my early married years, when money was scarce and the furniture consisted of peach crates and concrete blocks spread with boards. (Well, maybe it wasn't quite that bad. But pretty close.) Starting with that first apartment, I discovered that my identity wasn't defined by my surroundings or even my relationships. Sometimes when

there is no one else around, it's just you and the toilet in the middle of the kitchen. And that's okay.

Have you ever thought about who you really are? Strip away your roles, positions, relationships and titles and who is left? Too often we women get our identity through other people and the world's labels. We become defined by who we know, what we do and the reputation of our family tree. I seldom get called by my name. My husband sometimes introduces me as "my wife." My relatives refer to me as "my daughter" or "my granddaughter." My children tell others, "This is my mom." Their friends know me as "Emily's mom," "Dru's mom," or Lydia's mom." You may be called "the boss," "my assistant," "Doctor," or "Teacher." Since I write a self-syndicated newspaper column, I often meet people who ask, "Aren't you that newspaper lady?" It amazes me how consistently nameless I am. So, who would I be if I suddenly lost all these titles?

There is a popular radio talk-show psychologist heard around the country today. She starts her program each day by introducing her staff by name and assigned task. However, when she introduces herself to her radio audience, she proclaims, "And, I'm my kid's mom." She does this to make a point with her listeners. She wants today's parents to be responsible, taking their jobs as Mom and Dad very seriously. She expects them to be involved with their children. She hopes to attach meaningful significance to the titles Mother and Father. She is a strong advocate for children, encouraging parents to love and nurture their children. All of this is honorable and I commend her for it. But unlike the radio psychologist I do not advocate referring to yourself as "my kid's mom." It is not healthy to define ourselves through associations with other people, even our children. Relationships come and go. Job

titles are lost or taken. Husbands and parents die. Children grow up and leave. If throughout your life you have thought of yourself only as somebody's wife, someone's boss, or these kids' mom, you will face an identity crisis if you suddenly lose this title. If your identity depends on the stability of a given relationship, how will you feel about yourself when you are alone? How will you define your worth then?

This world is full of lonely people. They haven't learned to love themselves apart from their relationships and life positions. They measure their own worth by the people they know and the titles they hold. By doing so they feel empty, especially when life ruffles their identity. I married young and started having babies within a year and a half. Almost my entire married life has been spent mothering. If the radio doctor can claim, "I'm my kid's mom," then I can one-up her: "I'M MY KIDS' MOM!" For 12 consecutive years I stayed home to raise my three children. Even when the last one went to first grade, I only worked outside the home part time. I rarely missed a school party, program, play, concert, ball game or conference. I was almost always home when they got off the bus at the end of the school day. And I spent every summer at home with my children, seldom leaving them with baby-sitters. Everything I did, every decision I made, was done with my kids in mind.

So you can imagine what happened when my oldest child graduated from high school and went away to college. That's right — I fell apart. A piece of my world collapsed and a part of my soul walked out the front door with my daughter. I thought I had prepared myself for this major event. I read books about the empty nest. I talked to mothers who had already experienced the roots to wings phenomenon. I prayed. But I was still a mess

during my daughter's entire senior year of high school. Each time she did something at school, my comment was, "Oh, that's the last time we'll ever see her do that!" And when we left her on the college campus for her freshman year, I disintegrated into a blubbering heap. I didn't know it was possible to feel homesick when someone else leaves home, but that describes how I felt for the next nine months. Having two other children at home, I will have to endure this kind of heart pain two more times. What do you do when your children have been your life and now that life is coming to an end? Sending my daughter to college was my first realization that I need an identity apart from my children and all other relationships and life positions. I need to know me. You need to know you.

There are many lonely times in life. When a little child goes off to school for the first time, he understandably feels anxious about leaving home and spending the day with strangers. If he has spent the past five years growing up with a stay-at-home mom, he may struggle to find a new identity apart from her. The same can be said for older children. College freshmen are some of the loneliest and most perplexed people on the planet. They may be excited about being on their own, but it doesn't take long before they realize every shred of stability they have enjoyed for the past 18 years has been left at home. It's up to them to adjust to a roommate, a class schedule, unfamiliar buildings in an unfamiliar town, and managing their own money. Suddenly, no one asks if they've done their homework. No one urges them to get up on time or to be safe while driving. These kids soon realize the truth: no one in their new surroundings cares what they do, how they do it or even if they do it. What once shouted freedom and independence, now looms silent and lonely. Only a letter from home or a familial phone call reminds

them they are loved. For the first time in their lives college freshmen must face themselves. They begin to ask questions like, "Who am I?" "What am I going to do with my life?" and "Is this what I believe is right or is it just what my parents taught me?" The road to self-discovery is often rocky, painful, and lonely.

Childless women sometimes describe themselves as incomplete. If only they had children, they would feel more whole, they explain. Grandparents often get depressed following a visit from their children and grandchildren. The constant reentry and departure of grandchildren reminds grandparents of life's brevity and the vast chasm of miles that separates loved ones. The unemployed struggle with identity. How can you be someone without a job, title or income, they wonder. Divorced and widowed people feel equally lost. When defined in part by another person, who do you become when that person dies or leaves? How can you ever feel whole again when the partnership no longer exists?

Even missionaries report identity problems and feelings of loneliness. Everything familiar has been left behind to teach others about Jesus Christ. A missionary family from Kansas now serving in Brazil told me that whenever they come back to the United States to visit, they feel like societal misfits. "Each time we come home, the changes here remind us that we are no longer Americans, yet we aren't Brazilians, either," they explained. "We have eaten native food, learned several languages, and participated in many customs. Yet no matter which country we are in, we feel like outsiders."

I imagine Mrs. Noah had her share of identity struggles. It is not easy to find your place in the world when your family becomes a laughingstock. Genesis chapter 6 describes the world as an evil place to live at that time.

"The LORD saw how great man's wickedness on the earth had become, and that every inclination of the thoughts of his heart was only evil all the time. The LORD was grieved that he had made man on the earth, and his heart was filled with pain" (Gen. 6:5-6). And we think things are bad now! In those early days people were evil and so were their thoughts. Mankind was so wicked that God was sorry he had even made human beings. I sometimes wonder how God can stand the evil we generate in today's society. But compared to the days of Noah this is nothing. There is somewhat of a balance between good and bad today. But in Noah's time the bad tipped the scales.

This evil would have seriously dampened Mrs. Noah's life. Being a God-fearing woman, she undoubtedly had trouble finding like-minded women to invite over for coffee. She wouldn't have dared leave her three sons with a baby-sitter for fear of what they might learn. I'm sure she home-schooled. It wasn't safe for Mrs. Noah to go anywhere by herself because "the earth was corrupt . . . and . . . full of violence" (Gen. 6:11). And she must have worried night and day over her husband's unscrupulous business contacts. "Noah was a righteous man, blameless among the people of his time, and he walked with God" (Gen. 6:9). Being righteous and blameless in a wicked society doesn't win many friends. While Noah went home to his wife and children at the end of each day, other men had affairs and hung out in bars, laughing at Noah's righteousness. Wicked people don't take kindly to blameless men. Noah's goodness probably made others in his community feel shamefully uncomfortable. And when they couldn't drag Noah and his family down into the gutter with them, they most likely either taunted the Noahs or alienated them.

As if Mrs. Noah's life wasn't lonely enough, her husband got a heavenly message to build an ark — a HUGE, three-story ark.

"You're going to build a what?" Mrs. Noah asked her husband that day.

"An ark — kind of a giant boat. God says to make it 450 feet long, 75 feet wide and 45 feet high. It has to have a roof and three decks," Noah explained.

"What ever for? Do you know what this is going to do to our family budget?"

"Well, God says He is going to flood the earth to get rid of all this wickedness we have to put up with every day. He says we're the only family he's going to spare. The downside is we have to live for awhile inside the ark."

"Noah, what is a flood, for heaven's sake?" Mrs. Noah inquired.

"It's more water than you can imagine. So much water that everyone will drown when it covers the entire earth."

"What about all the animals? Don't tell me they are all going to drown too." Mrs. Noah was trying to comprehend. "Noah, you know how much I love animals."

"I'm glad to hear you say that, my dear," Noah smiled, "because God says we have to take at least two of every kind of animal on board the ark with us. Now, I've got to get started before it rains."

"Hey, what's rain?" Mrs. Noah called after her husband as he headed out the door, his ax slung over his shoulder.

Forgive me for this imaginary conversation. We don't really know what Mrs. Noah said when her husband broke the news of ark construction to her. She must have been a woman of great faith to stand by as Noah spent years and years crafting the huge boat and stocking it with

food. She must have had confidence in her husband's relationship with God while she and her family sat locked inside the ark, waiting an entire week before the first raindrop fell, while mocking laughter permeated the ark walls from those outside. She must have had great strength of character to turn a deaf ear to the wicked community who surely taunted Noah for his ongoing project. Her soul must have been tormented at the sound of her evil neighbors' incessant pounding on the ark walls and their desperate screams as the floodwaters rose higher and higher. She surely had tremendous patience to be imprisoned for over a year inside the ark with her husband, her three sons, her three daughters-in-law and all those smelly, noisy animals. Through it all I will also wager that she experienced big doses of loneliness. When she looked around at her community, did Mrs. Noah ever ask, "Who am I and what am I doing here?"

We often ask the same questions. There are a few things about our identity we can know for certain. If we come to understand the benefits of the following information, we can avoid the pain of identity confusion. First, if you have ever felt alone, you are in good company. Jesus knew loneliness. He was misunderstood, falsely accused and ridiculed by others. His mission took Him away from His family. His death temporarily separated Him from His Father. His closest friends repeatedly questioned His actions; one betrayed Him to the enemy and the rest abandoned Him in His greatest time of need.

Paul, too, was alone many times. After becoming a spokesperson for the Christian cause, this Jew and former leader among the Pharisees suffered alone many times. He was beaten, left by the wayside to die, shipwrecked and stoned. He was imprisoned several times, where he spent hour upon hour writing letters of encouragement to

Christians. Once respected and honored among the most important Jews, Paul was despised and tormented by these same people following his conversion to Christianity. This change in beliefs and life direction would cause most people to question their choices. Trading a revered position for the job of preaching the gospel while hungry, tired and tortured could certainly bring about an identity struggle for most of us.

What Jesus and Paul knew was that being in the minority often brings greater rewards than running with the crowd. Noah would have perished if he had joined the majority. We would all die in our sins if Jesus hadn't been willing to be counted as different. The gospel would not have spread if Paul would have gone back to the popularity of his former position. Each of these realized brief ostracism was worth eternal benefits. We need to believe there are worse ways to live than alone.

In fact, being alone often has many benefits. When we remove all that we are in the world's eyes and get alone with God, our lives change. Don't believe me? Look at Jonah. Spending time alone inside the dark belly of a giant fish gave Jonah three days to think about the benefits of obedience. Saul spent three lonely days without eyesight in order to hear divine instruction about the rest of his life. The Prodigal Son would have never come to his senses had he remained around people. It was his alone time with the pigs he tended that drove him to repentance.

"Jesus often withdrew to lonely places and prayed" (Luke 5:16). Jesus understood the rewards of spending quiet time alone talking to God. With a hectic life meeting the needs of hurting people, Jesus spent time alone to get refocused and recharged. We, too, lead busy, chaotic lives. If you don't take any time to be alone and still, how will

you hear God's voice? God urges us to, "Be still and know that I am God" (Ps. 46:10a). While the world equates being alone with pitiful loneliness, a believer views it as fellowship with God. There's nothing lonely about that!

You may not like knowing this, but God calls Christians to be misfits.

> Dear friends, I urge you, as aliens and strangers in the world, to abstain from sinful desires, which war against your soul. Live such good lives among the pagans that, though they accuse you of doing wrong, they may see your good deeds and glorify God on the day he visits us (1 Pet. 2:11-12).

Have your children memorize this verse. Christian children often feel alienated by their peers at school. Christian teenagers struggle between wanting to be popular and upholding godly standards in a public school setting. Whenever I visit my children's school and hear the foul language and see the rude ways kids treat each other, I pray all the harder for my children's faith and character strength.

It helps to know that Jesus was not considered popular by the masses, yet look how unforgettable he continues to be even 2,000 years later. Anyone can go along with the crowd, but only the strong in identity can stand with the minority and do what is right. Many times we will feel like "aliens and strangers" in this world, but we will feel right at home in heaven! The trade-off will be worth it.

The truth is, we humans have a propensity toward idolatry. If our identity comes from who we know and what we do, then the focus of our worth shifts from God to others and things. The world tells us, "Buy the little, red sports car if you want to stay youthful. Clothing labels make the woman. You'll never be someone if you live on *that* side of town. Climb the ladder — don't worry who you push aside

on your way to the coveted title. Your children must be gifted athletes and academic whiz kids to prove you are a worthy mom. Want to get into this sorority? Then how much money does your father make? Call us here at the country club when your husband gets to be CEO." If these are the things you are trying to achieve in order to define yourself, then you are falling prey to idolatry.

The Bible is filled with examples of those who tried to become someone through idolatry, which is placing anything in greater significance than God. The tower of Babel was built to "make a name for ourselves" (Gen. 11:4). Isaiah 44 tells us about blacksmiths and carpenters who used their God-given talents to fashion idols. While Moses was receiving the Ten Commandments, his brother Aaron stayed behind at the bottom of the mountain casting a golden calf for worship with his friends. These aren't just Old Testament Bible stories. They are warnings concerning the consequences of placing something ahead of God. We are guilty of idolatry when our identity is defined through our things, our titles, and our relationships. Even our children can become idols if they are the source of our self-esteem. We are called to keep ourselves free from idols (1 John 5:21).

If you struggle to have a strong sense of self-worth, stop defining your identity through your things and other people. Learn to see yourself as God sees you. In an earlier chapter we discovered that we are children of God. Spiritually speaking, you are the daughter of a perfect Father. He knew you before you were born and knows when you will die (Ps. 139:13-16). He knows you quite intimately — how many hairs are on your head (Luke 12:6-7) and the thoughts and attitudes of your heart (Heb. 4:12-13). He determined the proper time in history for you to live and the setting in which you would be

most likely to reach out for His love. (Acts 17:26-27). He also knows your name (John 10:3, 14-15). All Christians have this promise: "He who overcomes will, like them, be dressed in white. I will never blot out his name from the book of life, but will acknowledge his name before my Father and his angels" (Rev. 3:5). Not only does Jesus know your name, He will use it to introduce you to God on the day you get to heaven. Jesus does not know you as "her kid's mom" or "that man's wife" or "this person's assistant." He knows you by your name and will use your individual name to welcome you into heaven before the Father and the angels!

Even in the absence of human relationships and positions you are never really alone. The omnipotent, omnipresent God of the universe is always with you. He is there in good times and bad. He goes to work with you each day and is by your side on vacation. He's at home and at school. He greets you each morning and watches over you through the night. Nothing can stand between you and God's love. "For I am convinced that neither death nor life, neither angels nor demons, neither the present nor the future, nor any powers, neither height nor depth, nor anything else in all creation, will be able to separate us from the love of God that is in Christ Jesus our Lord" (Rom. 8:38-39). God is involved and invested in you. You are definitely not alone. And you never will be. As Deuteronomy 31:6 promises, "[T]he LORD your God goes with you; he will never leave you nor forsake you."

Many of us believe these biblical truths in principle. Theoretically we know God is always with us, therefore we are never alone. But life has not demanded we test this beyond our intellect, allowing it to penetrate our hearts. Let me tell you about Gary. Gary was a social man. He knew everyone in his small hometown and everyone knew

him. Gary and his wife owned the local grocery store. It was Gary's habit to greet each customer and chat for awhile if they could afford the time. He served on local councils and was involved in various clubs and church activities. There wasn't a single person who didn't like Gary, and he counted himself blessed to have so many friends. But one day Gary noticed his legs felt rather weak. His hands began to go numb and he started stumbling even on a smooth sidewalk. The doctor's diagnosis was devastating: multiple sclerosis.

Over the next few years, Gary's condition worsened. He used a wheelchair to greet customers. He limited his working hours, and eventually he and his wife sold the store. Gary missed the people and his position in the business community. Many people walked right past his wheelchair without speaking and few came to the house for a visit. Gary is now completely paralyzed. He spends his time at home, receiving daily physical therapy and personal care from his wife. This once popular businessman now sits at home in his wheelchair or lies down in his bed for long periods of time. MS has even claimed his windpipe and esophagus, making it difficult for Gary to swallow food or talk above a whisper.

Not long ago I was assigned to report on how multiple sclerosis affects its sufferers. I interviewed Gary for the article. What struck me most about this middle-aged man was his positive disposition. He has lost his independence, his business, his professional place in the community, his club involvement, his ability to physically function, and many of his friends. He is totally dependent on his wife for even the simplest of tasks while he waits for death to knock at his door. And here he was smiling while I asked about his condition.

"Gary, how in the world do you keep from getting depressed when you realize how much of your identity has been stolen from you?" I posed.

In a raspy voice, broken by attempts at taking in enough oxygen, Gary responded, "That's easy. Do you know my friend Jesus?"

Even in the face of a horrible, cruel illness like MS, Gary realizes he is not alone. He knows he is a child of God and that his name is written in the book of life. His identity is not defined by his disease or even by what he has lost. Gary's self image comes from knowing Jesus. In times of aloneness, he seldom mourns what he once had. He doesn't condemn those friends who neglect to call. He doesn't resent the new grocery store owners. Instead Gary celebrates a friendship with the Savior. He finds identity in God's promises for a better life — eternity in heaven — where his friend Jesus will one day announce, "And, Father, I'd like you to meet Gary.

Reflecting on My Face as Just Me

Numbers 6:2-8

You are called to be separate for God. The Nazirites had vows of separation. What would your vows of separation include today?

How difficult is it for you to live a separated life?

Can others recognize that you are different from the world?

Romans 8:38-39

In this list, which of these things tug at your self-worth?

What other factors or entities threaten your identity before God?

Psalms 68:5-6 and 146:7-9

What are God's promises to the lonely?

Which of these do you relate to in your own life?

How have you seen these promises carried out for others?

Matthew 3:17

Jesus was the Son of God. You are a daughter of God. Imagine God saying these words at your baptism.

How does this impact your identity?

Do you believe this is how God feels about you?

Matthew 28:20b

Why was it important to the disciples that these be Jesus' last words on earth?

What do they mean to you?

Do you live like you believe it?

Life in the Cul-de-sac

❦‡9‡❧

When you move 13 times in as many years, you meet a lot of neighbors. My most adventurous move was in 1986 when Bert and I loaded up all our worldly possessions, the kids and the family dog, and headed for South Carolina. It took the better part of three days to trek from Kansas through the mountains of Tennessee, finally landing in our new destination. By the time we arrived, I was exhausted. In this era of moving companies and airplanes, most people considered us a little backward for moving ourselves with a U-Haul truck. Like our pioneer forefathers we set out without a place to live upon arrival. We figured if our great-great-great-grandfathers could fashion a soddy on the prairie, surely we could find a rental house in the suburbs.

Bert's new boss arranged for us to meet with a real estate agent the same day we pulled into town. Already worn out from our journey, we tromped from rental house to rental house, assessing each piece of property and its corresponding school district. Half-a-day and three whining children later, we were shown a brick rancher hunkered amidst towering pine trees. The outside of the house was pretty; the inside needed major help. Inspecting the property room-by-room, I was horrified to discover green shag carpeting, dark paneling, heavy drapes, and hideous wallpaper in loud, floral patterns. This house was definitely not me, but we were exhausted. Ater spending three days in a station wagon, the kids were anxious to unpack their toys. With only slight hesitation we signed a year's lease and began unloading our boxed belongings.

My moods are dictated largely by surroundings. Put me in a home with bright white walls, lots of sunny windows and antique quilts, and I'm quite happy. Plunk me down inside a house like the South Carolina one and I'll be depressed. I brainstormed

ways to make the fluorescent, flowered wallpaper less nauseating. But, rental hous-
es belong to other people. There wasn't much I could do about the dreary interior
design. Thankfully, South Carolina is blessed with beautiful weather practically all
year long, so I spent most of my time outside, away from the glaring color scheme
that threatened to fry my retinas.

About a week after moving in, my youngest child and I were stretched out on a
blanket in the front yard reading Dr. Seuss books. Suddenly I heard approaching
sirens and an ambulance pulled up across the street. Two paramedics jumped out,
medical equipment in tow. Minutes later they carried a man out of the blue house
directly across the street. A frantic looking woman watched as her husband was
loaded into the back of the ambulance and whisked away. Her three small children
cried on the front porch.

I told my daughter to stay put and I dashed across the street to offer my assis-
tance to the distressed looking woman.

"We haven't met yet, but my family just moved in across the street," I said to
my teary-eyed neighbor. "May I take care of your children so you can go to the hos-
pital?"

"Thanks, but I've already called a friend," she told me. About that time the
friend pulled up and drove away with the woman and her children.

A few days later after being treated for a bleeding ulcer, my neighbor man
came back home. I walked across the street again, this time to ask the family over
for dinner. We were anxious to make friends in our new neighborhood and this fami-
ly seemed a good place to start. They accepted my invitation.

Our two families instantly connected that evening. Our children were about the
same age and played together after supper. The four adults swapped stories in an
effort to get acquainted.

"Ya'll are the first people in this neighborhood to even speak to us," Linda, my
new South Carolina friend, told me as we washed the dinner dishes. "It really means
a lot that ya'll would invite us over."

"How long have you lived here?" I asked, thinking maybe they had just moved
into the neighborhood as well.

"Two years," she responded.

I was stunned. Linda told me prejudice in the old South wasn't completely dead.
She and her husband Terry are black, and the rest of the block, like Bert and me, was
white. Sadly a color difference had stood in the way of neighborliness. We vowed to
see change. We planned a barbecue in the cul-de-sac. Next came a neighborhood
garage sale, a July Fourth fireworks display, a Christmas cookie get-together and a
kids' Easter egg hunt. Before long our neighborhood became family. Neighbors no
longer saw skin color, but friends. We refused to let age, occupation, race, or religion

choke out relationships. A bleeding ulcer and an ugly house produced the beginnings of community. Time, effort and a positive spirit kept it growing.

In the olden days families lived close to each other. It was common for a child to marry and build a house next to her parents' house on the family farm. Immigrant families often journeyed to the new land together. Once settled they worked and saved and pooled their money to bring additional family members over to join them. Pioneer families traveled westward by wagon train in hopes of owning land. Together they established towns and built churches, stores and schools. They carved out a life that included each other. In times past, shared heritage and blood ties were often woven together to create community.

Today job transfers separate families, while advanced transporation and complex communication systems enable them to connect across thousands of miles. It is rare nowadays for a woman to grow up, marry and settle for the rest of her life in the same town. Our high-tech, mobile society doesn't allow it.

My grandfather was a house painter. He could always find work in his hometown and never considered moving out of state for a job. Now people have more specialized skills that often call for relocation to maintain job security. Jet planes, fax machines and computers are the norm. Layoffs and downsizing force people to abandon their roots and seek employment in other locations. Sometimes it means moving half a world away.

Young women no longer walk across the street to ask their mothers for homemaking advice. Men don't go fishing with their fathers on Sunday afternoons or solicit their help in rebuilding an engine. Today's grandparents might only see their grandchildren once or twice a year, one

weekend at a time. And when they do, they barely recognize them from the last visit because the kids have grown so much.

After she died, I read the diaries my great-grandmother had meticulously kept for more than 50 years. In those pages she described doing the laundry every Monday with her married daughter, who lived only a block away. She wrote about family dinners held at her house each Sunday after church. She recalled shopping trips with her adult daughters and reveled in the relationships she had with each of her nearby grandchildren and great-grandchildren.

Today's elderly are not as fortunate. They must rely on the telephone and the post office to maintain family ties. Young people don't fare any better. Many children in America today don't know the privilege of a grandparent in the audience during a school program. Most are deprived of family legacies that grandparents bestow. It's hard to inspire the youth of today without the wisdom of previous generations. There's no one to blame, really, for the miles that separate modern-day families. Few of us purposely choose to disconnect. Distance between loved ones is merely a sign of our times.

So God in His goodness gives us neighborhoods. A neighborhood is like a family. Take a look at yours. Mine offers a blend of age, background and economics. On my block there are a handful of retired couples, several families with small children, and middle-aged folks whose teenagers' cars line the curbs. Each neighbor brings a uniqueness to my street. One has a prize-winning lawn. Another keeps the neighborhood cars in tip-top condition. There's a doctor, a publisher, a real estate agent, a pharmacist, a school teacher, a police officer, a counselor and several business owners. Some neighbors are friendly, while the more private ones keep mostly to themselves. I wouldn't

have chosen all my neighbors if given the opportunity. But who would choose every one of their relatives, either?

Proverbs 27:10 tells us that in times of need, "better a neighbor nearby than a brother far away." Think of those who have experienced the devastation of an earthquake, the ravages of a flood or the destruction of a tornado. The most compassionate people in such times are others in the community. When a fire destroys a home, it's usually the neighbors who offer food, clothing and shelter. When a tornado rips through town, neighbors collect scattered belongings and eventually rebuild together. When an earthquake rattles a community, the residents of that city spend long hours searching for the injured and comforting each other. When a hurricane approaches, neighbors organize to board up windows and plan an evacuation. They are the ones who understand because the disaster is happening to them as well.

Family members living in other locations can try to sympathize. But unless they have experienced the same kind of disaster, they aren't equipped to be supportive like those living through the crisis together. Neighbors, like yesterday's families, provide each other with safety, security, fellowship, friendship, aid, service and comfort. In certain situations they are the only ones qualified to help.

I grew up seeing the importance of neighbors. Most of my childhood years were spent on a farm. The nearest neighbor was a half-mile away. But in rural communities, people watch out for each other, often working together to harvest crops, build fences or vaccinate animals. My grandparents knew their neighbors well. They shared produce from their garden and tidbits of news across the hedges that separated yards. My great-grandmother took me with her to visit neighbors. She would chat with them in the living room or drink lemonade on the front porch. I tagged along

when Granny walked a blind neighbor to church each Sunday morning. She showed me the gift of neighborhood interaction and the blessings of next-door connections.

Being a good neighbor takes effort and thought. Sometimes I feel guilty about how often I merely wave at my neighbors as I back my van out of the driveway to rush off to this activity or that event. With our hectic lives today it's not easy to know all the neighbors by name, much less stay involved with them. But by looking at the neighborhood as a family entity, it seems logical to do so. There are great benefits to children, with far away grandparents, to have surrogate grandmas and grandpas on the block. Elderly neighbors, whose families live elsewhere, are blessed when young people nearby help them with tasks or drop by for a visit (with a parent's knowledge and consent, of course). Newlyweds can learn a lot from a mature couple down the street. Mom and Dad aren't around to give advice, so an experienced couple in the neighborhood can temporarily fill the gap. When neighbors interact for the good of each other, a residential family is formed.

Seven times God commands us to love our neighbors as ourselves (Lev. 19:18, Matt. 19:19, Mark 12:31, Luke 10:27, Rom. 13:9, Gal. 5:14 and Jas. 2:8). He could have told us once, but instead, peppered this message of neighborly concern throughout the Bible. This concept is easy to understand if you remember your growing up years. In your childhood home, you most likely had certain ground rules that enabled you to coexist with your siblings somewhat harmoniously. Don't hog the bathroom. Share the television. Keep your stuff on your side of the room. Don't borrow clothes without permission. Limit phone calls to 15 minutes each. Leave your sister and her boyfriend alone. And, please, no tattling!

Neighbors, too, have ground rules if they want to avoid conflict. The Bible has much to say about neighbors living cooperatively. Two of the Ten Commandments directly address the issue of neighbors. The tenth says "You shall not covet your neighbor's house. You shall not covet your neighbor's wife, or his manservant or maidservant, his ox or donkey, or anything that belongs to your neighbor" (Exod. 20:17). If we were to write a modern-day version of that verse it might read, "You shall not be jealous of your neighbor's new house. You shall not proposition her husband. You shall not desire her new Jaguar, swimming pool, money, housekeeper or anything else she enjoys." In other words, forget about keeping up with the Joneses. They have their things, you have yours. Be happy with what you have and appreciate that others also have blessings. In so doing, you are loving your neighbor as yourself.

The verse just before reads, "You shall not give false testimony against your neighbor" (Exod. 20:16). For everyone on the block to get along, lying and gossiping must be avoided. You must see and live near your neighbors day after day. It will be much easier to face them with a clear conscience if you have not spoken maliciously about them to other neighbors. Refuse to listen to neighborhood gossip.

The Bible gives further instruction about loving our neighbors as ourselves. Leviticus 19:13 warns against defrauding a neighbor. Verse 15 encourages judging our neighbors fairly. And verse 16 advises not to do anything to endanger a neighbor's life. These principles should be practiced by neighborhood adults and passed on to neighborhood children.

One Fourth of July a group of adolescent boys decided to set off strings of firecrackers in our street. Unsupervised,

these boys soon tired of their game and looked for more daring adventure. So they dragged a large piece of cardboard into the street and torched it with cigarette lighters. Towering flames quickly shot up. The boys laughed in delight; I didn't think it was funny. Opening my front window, I shouted for them to get a hose and douse their experiment with water. To my horror, they instead scooted the flaming cardboard to the nearby storm sewer and chucked it inside, causing the sewer to burn orange from underneath the curb. I began fretting about the location of the main line that provides natural gas to our neighborhood homes. Fortunately, the fire died out before our block blew sky-high. That night I certainly wished the neighborhood boys had been taught Leviticus 19:16!

There are many practical ways you can love your neighbors as yourself. Simply put yourself in their place. When a new neighbor moves in, remember how it feels to be the new face on the block. Take over a meal and a handwritten list of your town's best doctors, dentists, babysitters, dry cleaners, grocery stores and restaurants. Organize a neighborhood coffee to welcome them. When a neighbor gets sick or has an operation, send flowers, cook a casserole, clean the house or watch the children. When your neighbor goes on vacation, offer to pick up the newspaper and the mail and water the garden. If you have an elderly neighbor, check in from time to time or invite her over for a visit.

If you don't already know your neighbors, that's the place to start. Introduce yourself, wave when you come and go, and speak when you're out in the yard. Stay in touch. I'll never forget how badly I felt when I went next door to retrieve the flowers my mother had sent for my fortieth birthday. I was at work that day, so the floral shop delivered my bouquet next door and left a note telling me

where to find it. After I rang her doorbell, my neighbor lady came to the door. She was bald. I felt like the world's worst neighbor when Jo told me she was receiving chemotherapy treatments for ovarian cancer. If I had been a caring neighbor, I would have known about her illness and been more supportive.

I am not advocating becoming the neighborhood pest. Neighborliness can be overdone. Proverbs 27:14 is humorous, but also holds a pearl of good advice. "If a man loudly blesses his neighbor early in the morning, it will be taken as a curse." There is a proper time for everything, even blessing your neighbor. Let her have a little peace and quiet. I have known apartment-dwelling neighbors who thought they were blessing me with their loud stereo at all hours of the day and night. I also had a neighbor who thought everyone on the block should share everything, starting with my vacuum cleaner. Whenever her apartment got dirty, she decided to pay me a little visit, worming in a weekly request to borrow my vacuum.

In families, people need their own space. So it is in neighborhoods. "Seldom set foot in your neighbor's house — too much of you, and he will hate you" (Prov. 25:17). If you make a perpetual pest of yourself, your neighbors just might hide behind the couch and refuse to answer the door when you come calling. Try to balance neighborly contact with a little privacy.

Remember how you used to draw an invisible dividing line down the middle of the bedroom you and your sister shared? Well, neighbors also have dividing lines and we should respect them. Deuteronomy 19:14 warns, "Do not move your neighbor's boundary stone set up by your predecessors" In Bible times, inherited land was marked out by boundary stones. Neighbors were asked to respect each other's property by not tampering with the

markers. To cheat a neighbor, the land-owner next door got up in the middle of the night and moved his neighbor's boundary stone. This gave the appearance that the cheater's property was bigger than it legally was. Today we have fences and hedges that serve the same purpose. Many a neighborhood dispute has erupted over fence placement or the planting of a few trees. Sawing off a neighbor's tree branches or letting your kids climb over his fence is not very loving.

The principles of neighborly love should be applied to a much broader scope than your cul-de-sac or apartment building. Jesus was once asked, "Who is my neighbor?" (Luke 10:29). Using the parable of the Good Samaritan, Jesus taught that our neighbors are those we come into contact with everyday. To be good neighbors, we must keep our eyes open to the needs of others and do what we can to meet those needs. If your neighborhood is like family, then your community is an extended family.

Before moving to town, my newest neighbors researched where they wanted to spend the next few years of their lives. They studied schools for their children, placed an emphasis on culture, sought racial balance, and looked for a low crime rate. They wanted a community that cares about its people, maintains its parks and preserves its historical past. My neighbors realized that a community directly impacts the quality of life for its inhabitants and so they chose carefully.

A community is only as good as its people. Wherever you live, keep a pulse on your community. Vote, read the newspaper, stay abreast of local government, serve on a board, and learn about the town's educational standards. Deborah, the only female judge in the Old Testament, kept tabs on her community. This wife and mother held court under the palm trees and settled disputes among

her people. Too often people get blasé about their town. Seeing themselves as only one voice, they don't get involved because they fail to realize they can make a difference. But you'd be surprised what one voice like Deborah's can do.

In the Bible Nehemiah was only one man. Yet in spite of opposition he organized the people and built a community out of a broken down wall. Jonah was only one person. But once he decided to obey God, he spared an entire community from annihilation. Dorcas was only one woman. Yet she was "always doing good and helping the poor" of her community. When she died, many widows mourned because she had compassionately made clothing for them over the years. (Acts 9:36-43).

You are only one person, but you can make a difference in your community. God especially challenges us to look after the needs of the poor, the helpless and those in trouble. Deuteronomy 15:11 tells us there will always be poor people among us. However, we must guard against getting hardened towards them. "I command you to be openhanded toward your brothers and toward the poor and needy in your land." Not only are we to serve those considered brothers — people who share a common bond with us — but also the downtrodden. Communities have many ways of helping the poor. Most towns have established soup kitchens, homeless shelters, and resale and thrift shops.

Many people believe their taxes serve the poor, relieving them of any further personal responsibility. While it is true that many government programs exist to help the needy, some people still get overlooked. God expects us to help. You never know when disaster may strike you next. Unemployment, a devastating fire, or long-term illness can catch anybody off guard. "If a man shuts his ears to the cry of the poor, he too will cry out and not be

answered," Proverbs 21:13 warns. If God puts a need in your path, He wants you to handle it. But be prepared to be blessed for your generosity more than the recipient is!

Each community has its "helpless." Children depend on others for safety, food and shelter. When their parents can't or won't provide for their needs, other people must step in with assistance. We can be stirred to compassion by pictures of starving Ethiopian children but refuse to see abused or neglected children in our own hometowns. Children can't help themselves. They are at the mercy of others to provide assistance. You can help a child. Volunteer in a neighborhood grade school helping young children learn to read. Serve as a Court Appointed Special Advocate speaking on behalf of a child caught in the court system. Consider adopting a child or becoming a foster parent. Provide short-term care for children in need of emergency shelter. Become a Big Sister. Give money to the local Boys and Girls Club or chaperone a party at the teen center.

The unborn are especially helpless. As the abortion debate rages in this country, hundreds of unborn children lose their lives every day. You don't have to become a radical activist to protect the unborn. Pray for the world's babies. Write to legislators. Serve at a local home for pregnant, unmarried women. Volunteer at a pregnancy crisis center or donate your baby's outgrown clothing and equipment. Talk to your children and their friends about the grief associated with abortion. Make sure they understand the emotional value of sexual abstinence outside of marriage. When you come into contact with an unwed, pregnant teen — even in your own church — don't condemn her. Instead reach out in love and support her decision to carry her baby to term. Most young women don't want to have an abortion. Condemnation and shame force them into thinking there is no other way out.

Then there are those in trouble in our communities. Sin beckons to anyone not fully convinced of its repercussions. Alcohol and tobacco advertisements scream out to people of all ages. Illegal drugs are everywhere, including your local junior and senior high schools. Gangs threaten our youth, giving them a false sense of belonging. And the crime rate continues to soar, particularly among juveniles. Yes, there are plenty of people in trouble. Visit a drug and alcohol rehabilitation center and you will observe some of the most depressed people on the planet. Go inside prison walls and see what crime does to the soul. Once you've toured a rehab center or a prison, life will never look the same again.

I have had many volunteer jobs. Like most moms, I have served in school as room mother, library aide, classroom assistant, carnival organizer, field trip chaperone, and party overseer. I have also been on the board of the American Cancer Society, taught courses for Junior Achievement, sat on a few community councils, helped with fund raisers for the American Heart Association and been a counselor at Birthright, a pro-life organization. But the volunteer opportunity that has touched me the most is tutoring juvenile offenders in my community's detention center.

On my first day, I was a little nervous as the series of metal doors clanked shut behind me. I found myself face to face with a room full of teenagers, all awaiting trial for violent crimes. Some of the kids had been charged with murder. Some were accused of assault or gang-related violence. Most were alcohol or drug addicted. Many had stolen cars. All of them stole my heart.

Before arriving at the detention center, I pictured rough looking, tough talking teenagers. What I found instead were ordinary kids. After being stripped of their gang clothing and given regulation sweat suits, they

looked, sounded and acted like any other teenagers — even my own. But unlike my three children, these kids, for the most part, did not have responsible, caring adults in their lives. They lacked parents who were capable and willing to nurture, love, teach and commit to raising their children. Some of these kids had several relatives in prison. Just like going to college is expected in some families, it was a right of passage into manhood for these children to spend time in lockup.

The kids I work with at the detention center range in age between 11 and 17. Although they aren't ecstatic about spending time behind locked doors, most end up responding to the structure and discipline the center offers. Unbelievably, some kids say the center is the safest place they have lived. Unlike at home, they are served three meals a day and have a warm bed at night while in detention. They have rules, consequences, rewards and help achieving their goals. These juveniles all crave adult affirmation. They long to know they are valuable and have a place in this world. The center's staff strives to give them those things.

I was assigned to work with John on my first day in the center's classroom. John was a 15-year-old gang member from an average-sized Kansas town. The center's teacher told me he had not responded so far to anyone's help and she wanted me to try. Great, I thought, start me out on a hard one. But then I realized they were probably all hard ones. John wouldn't make eye contact with me when I tried to help him with his math. He fidgeted nervously in his chair, certain I would judge him if only I knew his offense. I had determined I wouldn't ask any kid what they had done to break the law. I figured they had enough adults questioning them and probably didn't need one more.

I had to find some way to let John know I wasn't there to condemn him, but to help him with his school work. My opportunity came at the end of our first hour-long session.

"You know, John, I'm very happy you were willing to work with me today," I told him. "Plus that, you worked really hard on your math. If you don't watch out, people around here just might be impressed with you."

"Naw, man. Nobody's gonna be impressed with me. I'm in lockup!" His answer struck something deep within my soul.

"I don't care if you are in lockup or at the local high school," I told him. "If you work hard, other people will notice."

John looked at me to see if I was genuine or if I was ridiculing him. For the first time that day, we locked eyes. It is amazing how that one, very small but positive remark began to change the way John saw himself. Before our time together, John felt condemned because he was in a juvenile facility. I hope my comment that day gave him vision for being something other than a criminal. From that day on, John asked to work with me for the duration of his time in detention. And I made it a goal to never leave the center without offering some word of praise or encouragement to every child I tutored. Each and every child has responded back to me in a positive way. One girl even told me she hated to leave the detention center because she would never see me again.

I'm not a hero, just one woman who took the time to care about hurting and troubled children. You can do the same. The Johns of your community are waiting. If you want to improve your community, start with yourself. If you want a better, safer neighborhood for your children, get involved. If you want to make a difference to someone

else, look to the helpless, the poor, or the troubled. And if you lack motivation, just remember these words of Jesus:

"Come, you who are blessed by my Father; take your inheritance, the kingdom prepared for you since the creation of the world. For I was hungry and you gave me something to eat, I was thirsty and you gave me something to drink, I was a stranger and you invited me in, I needed clothes and you clothed me, I was in prison and you came to visit me."

Then the righteous will answer him, "Lord, when did we see you hungry and feed you, or thirsty and give you something to drink? When did we see you a stranger and invite you in, or needing clothes and clothe you? When did we see you sick or in prison and go to visit you?"

The King will reply, "I tell you the truth, whatever you did for one of the least of these brothers of mine, you did for me" (Matt. 25:34-40).

Reflecting on My Face as a Neighbor

Proverbs 25:18

What harm is done when a neighbor lies about another neighbor?

How bad would these lies hurt and why?

Deuteronomy 5:21

Be honest. What does your neighbor have that you struggle not to covet?

What makes you want that possession? How would it enhance your life?

Why do you think coveting is such an easy trap?

How can you safeguard yourself against it?

Deuteronomy 18:9

Why is it important to pick your community carefully?

How vulnerable are you to following the crowd?

Does your community affect you and your children positively or negatively?

Proverbs 31:20

With all of this woman's responsibilities, why did she find time for the needy?

How do you think she helped the poor of her community?

What is one thing you could do to help the needy around you?

Proverbs 14:20-21

Why do we shun the poor and make friends with the wealthy?

Which one is your neighbor — the poor or the wealthy?

Psalm 72:12-14

How does God feel about the afflicted and the poor?

What is your attitude about your community's poor people?

What is needed for you to see them with God's eyes?

The Pain of Disappointment

⊰ 10 ⊱

Even before Anne and Richard got married, they talked about the houseful of children they would one day share. The discussion grew a little more intense soon after the wedding. Being from a large Italian family, Anne knew the value of family relationships. And as a preschool teacher, she had often reveled in the smiling faces of little children, hopeful for the day when she would have her own. So the newly-weds began trying for a baby to fill the bassinet they had prematurely purchased.

Months went by and Anne did not get pregnant. Those months turned into two years. The young couple read books, sought advice and counseled with doctors about conception. They tried every idea presented, even those that seemed a little outlandish. Anne took her basal temperature every morning before getting out of bed. She kept meticulous charts and graphs of her cycle. She tried certain vitamins and herbs. And she and Richard kept trying. Still no baby resulted.

A specialist recommended fertility testing. Richard was tested first. No problem was found. Blood work to check hormone levels, ultrasound tests and finally an exploratory surgery were scheduled for Anne. The diagnosis was endometriosis — a rapid growth of uterine tissue that was strangling Anne's ovaries and fallopian tubes. The doctor tried to remove the enemy matter the best he could, but there was so much. Too much aggressive cutting could result in damage to Anne's reproductive organs. The doctor didn't want to risk that. Instead he prescribed powerful fertility drugs. Anne didn't appreciate all the side effects, but she hated more the thought of never bearing a child.

As the years went by, Anne and Richard remained childless while all their friends began having babies. Anne did her best to be happy for the others, but her heartache

⊱ 153 ⊰

increased with each baby shower given in someone else's honor. Buying soft baby clothes for others was torturous. Seeing her friends grow into maternity wardrobes reduced her to tears. To ease her suffering, Anne began buying baby and maternity clothes for her own closet. Surely God would bless her very soon with a child.

"Why can't I get pregnant? I know I would be a good mother," Anne cried to Richard one evening. "Why does God give children to so many women who don't even want them and not to me?"

Richard had no answer. He was dealing with his own disappointment. He, too, longed to hold a child of his own.

Anne and Richard tried to conceive for nine long years. The doctors told them to travel, to find hobbies, to enjoy each other because they would never have a baby. However, he offered, they might consider adoption. Anne and Richard researched adoption agencies in their area. They weren't totally convinced they could adequately love another woman's child, but they weren't convinced they couldn't either. Together, they prayed, leaving the matter in God's hands.

One day while reading the Bible, Anne discovered this verse: "He settles the barren woman in her home as a happy mother of children. Praise the Lord" (Ps. 113:9). She called Richard at his office and excitedly told him she believed God had a child waiting for them to adopt. She was right. A one-day-old baby boy was placed with Anne and Richard. A year later another baby boy came into their lives. Anne and Richard finally had a family and they couldn't have been happier. Anne threw her fertility drugs in the trash can and focused on raising her sons.

Then, two years later, Anne began having health problems. She was so tired and felt sick all the time. The doctor said it was normal for any young mother with two babies to feel exhausted. But the condition persisted, even when Richard took over the night duties. Anne went back to the clinic. Fearful of getting her hopes up, the doctor ran a pregnancy test without telling Anne what he was doing. Anne waited in the examining room. Soon the door opened and her beaming physician stepped back inside.

"You're not going to believe this," he said, hardly able to contain himself, "but you are pregnant!"

No expectant mother could have been more ecstatic than Anne. Finally, a child was growing inside of her! The pregnancy passed quickly and soon Anne gave birth to a dark-haired son. Two years later, she and Richard were blessed with a daughter. This infertile couple are now the proud parents of four lively, healthy children. Their home is filled with laughter and love. And a cross-stitched version of Psalm 113:9 prominently hangs on the living room wall.

The Pain of Disappointment

Life has many paths. Some are flat and straight and easy to travel. The turns are clearly marked and the destination is predictable. Other paths wind and bend through beautiful scenery, providing serene stops and chances for spiritual renewal. Then there are paths leading up steep mountainsides. The climb is a struggle, but the view is spectacular once the hiker reaches the top. Some of life's paths compare to roller coaster plunges with drops so sharp the anxious rider's stomach lurches into her throat. Try as we might to avoid them, the roller coaster paths sometimes sneak up on us unexpectedly and force us to endure the ride.

When I was a kid, the roller coaster was my favorite carnival ride. At fair time my best friend and I rode all the roller coasters the carnival crew erected. From the moment we stepped into the seat compartment and the ride supervisor strapped us in tight, excitement began to build. The switch was thrown and the coaster cars began slowly climbing up that first huge hill. As we ascended, the steepness of the first hill flattened our bodies against the back of the seat. Tension swelled as we neared the top. The coaster paused momentarily at the very tiptop and then, with no further warning and no chance for escape, we rapidly plunged down the other side of the sharp slope. Racing downward at a supersonic speed, my friend and I emitted ear-splitting screams. It felt like falling to certain death as we pitched forward, nearly ejected from our seats.

Finally, reaching the bottom, the coaster continued through a series of twists and turns, dips and drops, with its passengers shrieking mightily. My friend hung on to me for dear life through each loop and bend. About the time we thought we couldn't survive another second, the roller coaster glided in for a stop on safe ground. There

was a split second of silence before everyone on board began laughing. Although her face had a ghostly paleness about it, my friend collected herself, turned to me and said, "That was fun! You wanna go again?"

Life can be as unpredictable as the roller coaster. Starting out you anticipate exciting thrills. However, we can't foresee which turns will produce them. About the time you've settled into a peaceful groove, along comes an exhilarating mountaintop experience or an unsettling, out-of-control descent. We venture down a variety of paths during life. We will enjoy many of the roads. A few we will barely notice. Some will be an uphill struggle. And a couple will plunge us, racing out of control, to seemingly imminent disaster. Maybe you are on that path right now. I urge you to keep traveling. Remember, at the end of the drop, a calmness awaits. So don't forego the journey; don't be afraid of the ride.

In thinking of those scary roller coaster plunges in life, I'm reminded of James 1:2-4: "Consider it pure joy, my brothers, whenever you face trials of many kinds, because you know that the testing of your faith develops perseverance. Perseverance must finish its work so that you may be mature and complete, not lacking anything." There is a purpose behind those sharp drops and treacherous curves. Pain experienced now will later produce faith, persistence, maturity and completeness. At the end of the plunge, there will be growth and peace. Victory often follows despair.

Life's disappointments are many. For some, disappointment comes from losing a job or failing to achieve certain dreams and goals. Others hurt because of broken relationships, including divorce or abandonment. Pain is a common by-product of infertility, miscarriage, stillbirth and children born with birth defects or life-threatening problems. Health problems are difficult. The unexpected

death or suicide of a loved one is extremely sorrowful. And if they choose to rebel, children can also bring grief. No one wants to endure these life experiences. We don't choose pain. However, it knows where to find us, sometimes barging into our lives like an unwelcome intruder.

Since we can't avoid life's pain and disappointments, we must learn how to cope. James reminds us, "The Lord is full of compassion and mercy" (5:11). God sees your pain and He hurts for you. He doesn't want you to walk the road by yourself or suffer alone. In Exodus chapter three, God's people were suffering under the burden of slavery and it was more than God could bear. "The Lord said, 'I have indeed seen the misery of my people in Egypt. I have heard them crying out because of their slave drivers, and I am concerned about their suffering. So I have come down to rescue them . . .'" (vv. 7-8).

So, God chose Moses to lead the people out of oppression and into the promised land. I relate to Moses. He was a fretter. He gave God every possible reason why he was not the best choice for Jewish spokesperson. Moses worried that the people wouldn't believe him credible as a leader. He feared they would not recognize the plan as being from God. He stewed about his inability to be articulate. He even begged God to send someone else. Moses was afraid of failure, and as bad as slavery was, at least it was familiar to him. The unknown caused Moses plenty of anxiety. But God countered all of Moses' fears, asking him to step out in faith and use his leadership to benefit thousands of others.

God calls us to do the same. Human beings like to control their own lives. We want to be the ones steering down life's paths. The trouble is we don't know the roads and we don't have a map that warns of disappointments ahead. Only God does. "For a man's ways are in full view

of the LORD, and he examines all his paths" (Prov. 5:21). God has a plan for your life, but you must get out of the driver's seat and give Him the wheel. "In his heart a man plans his course, but the LORD determines his steps" (Prov. 16:9). When something painful becomes part of your journey, you have to trust that ultimately, good will result. God might not have built the bumpy road in your life right now, but He does want you to travel it. On it, He will show you a lesson, an opportunity or a healing just up the road a little further.

Even if you don't know the outcome of the pain you are experiencing, God does. Solomon explained, "For there is a proper time and procedure for every matter, though a man's misery weighs heavily upon him. Since no man knows the future, who can tell him what is to come?" (Eccl. 8:6-7). Only God knows your future and He will guide you down the paths best suited for your spiritual benefit and personal growth.

Maybe you think God doesn't really care that you are hurting. If He did, you believe, He wouldn't put you through such terrible disappointments. The pain you suffer breaks God's heart. He couldn't stand to see the Israelites persecuted and so trained Moses to deliver the people out of slavery. Coming to the town of Nain, Jesus came upon a large crowd mourning the death of a widow's only son. "When the Lord saw her, his heart went out to her and he said, 'Don't cry'" (Luke 7:13). Jesus also felt the pain of sisters Mary and Martha when their brother Lazurus died. "When Jesus saw Mary's weeping, and the Jews who had come along with her also weeping, he was deeply moved in spirit and troubled. . . . Jesus wept" (John 11:33,35). Even ". . . an unloved woman who is married" (Prov. 30:23) brings heartache to the Creator of love.

The Pain of Disappointment

Shari married the man of her dreams. William was handsome, smart and ambitious. People liked him and he knew how to make things happen. Everyone said William was going places, and Shari wanted to be right there beside him when he did. They started out like most young couples, living in a small apartment as William's business grew. Soon they moved to a house, had a baby and bought a new car. Things were going well and Shari soon discovered she was pregnant a second time. William's client list increased almost daily, so he and Shari decided to buy a large home in the suburbs. The American dream was becoming reality for them.

One day, shortly after the birth of their second daughter, William failed to come home for supper. He had to work late and he was sorry, he said. But William began staying out later and later, missing many more suppers. Shari loved her husband immensely, but couldn't help but be suspicious of the time he was spending away from her and his children. Leaving her daughters with her mother, Shari drove to William's mechanic shop, wanting desperately to believe he was simply working overtime to provide a nice lifestyle for his family. But instead of finding him under the hood of a disabled car, Shari discovered him in the back seat with another woman.

We, like Shari, don't plan for disappointment and heartache. If we knew what was coming next, we would become paralyzed with fear — too scared to face another day. The reality is disappointment will occur at least once in your lifetime — probably more often. Students don't plan to fail a class. Employees don't count on being fired. Brides never dream of seeing their names in divorce statistics. Women longing for children don't expect infertility, miscarriage or stillbirth. Young mothers can't predict that their babies will develop severe health problems or die a

sudden infant death. Most widows never thought their aloneness would come so soon. No one decides to get cancer. Parents don't think it will be their teenager who dies from a drug overdose or gets killed in a traffic accident. And it's always someone else's child who commits suicide, smokes pot, runs away from home, joins a gang, or serves time in jail.

Any one of these situations can leave you lonely, depressed and severely wounded. Disappointment understandably produces emotional pain. Solomon said there is a time for mourning. Don't deny your pain. Acknowledge it and allow yourself adequate grieving time. It is not weak to cry. There is nothing wrong with grieving. No one can tell you how long it will take to heal, so don't feel guilty when it doesn't happen overnight. There is no quick fix or prescription for emotional pain. There are no rules for mourning. Seek out others who have trod this rocky road before you. Get professional help if the dark clouds of depression persist, threatening to devour you. And take heart from biblical examples that the sun will shine again. "But for you who revere my name, the sun of righteousness will rise with healing in its wings. And you will go out and leap like calves released from the stall" (Mal. 4:2).

There was a New Testament woman who had "suffered a great deal under the care of many doctors" and had endured 12 years of nonstop bleeding. Her health problems were a terrible burden to bear, but she found Jesus and he healed her. In the Old Testament Hannah longed for children. Her infertility was a source of tremendous sorrow and she prayed diligently for a child. God heard and answered her prayers with several children, including her firstborn son Samuel, who later became a prophet. Imagine the painful guilt King David experienced when told his baby would die as a result of his sins

of adultery, deception and murder. When the child perished, God mercifully blessed David and Bathsheba with another child. Even the Prodigal's Father in the New Testament saw sorrow turn to joy when his defiant son grew weary of hardships and returned home in obedience.

Do you see the pattern? Whenever people turned to God for relief, in time their pain was healed. In every instance, when they trusted God, good resulted from disappointment. It worked for the apostle Paul. In 2 Corinthians 4:8-9, he wrote, "We are hard pressed on every side, but not crushed; perplexed, but not in despair; persecuted, but not abandoned; struck down, but not destroyed." When life deals you a low blow, you suffer. Give yourself permission to grieve. However, you can either collapse in a perpetual grief heap or turn to God for deliverance. You don't have to walk life's paths alone. You have a Father who cares and wants to journey with you. He will pick you up when your pain seems unbearable. "If the LORD delights in a man's way, he makes his steps firm; though he stumble, he will not fall, for the LORD upholds him with his hand" (Ps. 37:23-24).

If God provided relief during biblical times of suffering, He will do the same for you. "In you our fathers put their trust; they trusted and you delivered them. They cried to you and were saved; in you they trusted and were not disappointed" (Ps. 22:4-5). Trust in God. Ask Him to relieve your suffering or to weave something good from the threads of your pain. In times of trouble, God is near. Don't shrink back from Him. He won't let you down — that's a promise straight from His word.

Abigail was married to a man none of us would want. The Bible describes her husband, Nabal, as surly, mean in his dealings, unapproachable and a drunkard. His name meant "Fool." (How would you like to be known as Mrs.

Fool?) He was also wealthy, but stingy. David and his soldiers had protected Nabal's flocks and servants from harm, yet when David requested food, Nabal rudely refused to provide any.

"Who is this David? Who is this son of Jesse? . . . Why should I take my bread and water and the meat I have slaughtered for my shearers, and give it to men coming from who knows where?" Nabal harshly asked in 1 Samuel 25:10-11.

Nabal's words provoked David to anger. He ordered his men to strap on their swords and prepare to attack Nabal and his servants. Luckily, one of Nabal's men took news of the impending doom to Abigail, Nabal's wife. The Bible describes Abigail as "intelligent and beautiful." We might wonder why such a woman would marry an undesirable like Nabal. But remember, Bible-time marriages were arranged through families or by fathers. Abigail probably didn't have much say in the matter.

Now Abigail knew her husband's faults. He was most likely rude to her, too. When she learned of David's plan, she quickly took action, arranging for huge amounts of food to be taken to David's troops. Abigail didn't tell Nabal she was giving his food away. She knew his character well and did not want to unleash his fury. Her only desire was to spare the lives of the men employed by her wicked husband. First Samuel 25 tells the complete story of Abigail's brilliance. Using eloquent speech, she demonstrated respect and hospitality toward David. She took responsibility for the situation without whining or pleading for her life. She flattered David by recounting his past accomplishments and instilled in him a vision for what he would become in the future. She also held David spiritually accountable, reminding him God had not authorized the slaughter of Nabal and his servants.

Abigail put her life in God's hands. Being Nabal's wife, she could have also been killed if David had not been distracted. Abigail trusted God and delivered a spiritual reminder to David. David's response to her efforts was,

> "Praise be to the Lord, the God of Israel, who has sent you today to meet me. May you be blessed for your good judgment and for keeping me from bloodshed this day and from avenging myself with my own hands. Otherwise, as surely as the Lord, the God of Israel, lives, who has kept me from harming you, if you had not come quickly to meet me, not one male belonging to Nabal would have been left alive by daybreak" (1 Sam. 25:32-34).

After David accepted her gift of food and words of peace, Abigail traveled home to tell her husband what had happened. True to his rotten character, Nabal was drunk, so Abigail waited until the next morning when he was sober to relay the story. Nabal was not nearly as tough as he pretended, because he fell into a coma when told how close he had been to annihilation. He died ten days later. When David learned of Nabal's demise, he sent for Abigail to be his wife.

A man's meanness wears on a woman's confidence and her sense of self-worth. Many women married to modern-day Nabals get beaten down over time. So how did Abigail maintain such focus? Why wasn't she scared for her own life? Because she kept her eyes on God. All those years of being married to a fool didn't defeat Abigail because she trusted God and remembered who she was in His sight. She didn't look to Nabal for her self-esteem. She looked to God. She didn't try to change or manipulate her husband. She let God control the situation. She didn't enable her husband's faults or make excuses for him. She accepted that Nabal's weaknesses were his alone and refused to suffer because of them. Abigail also didn't judge herself

by her husband's deeds. She truthfully assessed her situation and honestly confided in David about her husband's character. "[P]ay no attention to that wicked man Nabal. He is just like his name — his name is Fool, and folly goes with him" (1 Sam 25:25). Being a woman of strength and character, Abigail was honored by God for her forthrightness and faith.

You may be currently struggling to walk a painful path. I pray that you will take a lesson from Abigail. Don't deny your situation. Evaluate it and ask God to help you develop a plan for contending with it. Trust in Him and pray constantly. Don't attempt roller coaster plunges without God seated next to you. Like Abigail, speak truthfully to those who can help you. Take responsibility where you can, and where you can't, turn the matter over to your Father's care. There is an end to your pain. You just have to continue down the road where peace awaits. The path may be rough and jagged in spots, but the destination will be well worth it. Don't give up.

> And I heard a loud voice from the throne saying, "Now the dwelling of God is with men, and he will live with them. They will be his people, and God himself will be with them and be their God. He will wipe every tear from their eyes. There will be no more death or mourning or crying or pain, for the old order of things has passed away." . . . "He who overcomes will inherit all this, and I will be his God and he will be my son" (Rev. 21:3-4; 7).

Reflecting on My Face in Pain

Luke 6:20-23

Why are the poor, hungry, sad and rejected blessed?

If you are in the process of pain, do you belive you will laugh again?

What encouragement do you need?

Romans 5:3-5

The opposite of despair is hope. What do you have to be hopeful about?

Are you able to rejoice in your sufferings?

What qualities does suffering produce? Do you desire these things?

James 5:7-11

How does the example of a farmer fit with struggle?

What lesson can you learn from biblical prophets?

Do you trust God to be compassionate? What prevents you from doing so?

Hebrews 12:6-13

Hardship is sometimes discipline from God. How do you feel about that?

Do you view discipline as loving? Does God love you?

What is the by-product of a disciplined life?

Luke 15:1-10

Here are two disappointing losses. What efforts were required for recovery?

What would have happened if they would have given up the search?

What resulted from continuing the search in faith?

How did the woman's recovery of her coin impact others around her?

1 Samuel 25

In what ways do you relate to Abigail?

What lessons can you learn from her and implement to overcome disappointment?

Can you trust that God knows your plight and will bless you?

"Here Am I. Send Me!"

⇒‡11‡⇐

 My town is home to a large four-year university, so it seemed only logical when the church I attend decided to start a campus ministry. What didn't seem logical was the new campus minister asking me to lead a Bible study in a women's scholarship hall. I was 33, married, the mother of three children, and a part-time remedial math teacher. How could 18-year-old, single, college freshmen relate to me? Why would they attend a Bible study I was leading? Wouldn't they think I was some old lady who couldn't possibly understand them? I thought of many reasons why I was not the best woman for the job.

 Somewhat reluctantly, I agreed to try it. Flyers were posted in the scholarship hall. Each of the 50 girls living there was personally invited. I made my way through the hall's front door the night of the first study, introduced myself to the girl at the desk and asked if she knew where we were to meet.

 "I can show you," a voice announced, two flights of stairs away.

 I glanced up to see who my guide would be. A tomboyish young woman, dressed in athletic shorts, t-shirt and tennis shoes, bounded down the stairs two at a time. Taking the last five in one giant leap, she landed with a loud thump before me. If I didn't feel old before, I certainly did once this energetic creature appeared on the scene.

 "Hi, my name's Becky," she said, sticking her hand out in my direction. "I'm coming to your Bible study tonight."

 Becky led the way to an empty basement room. I glanced around wondering if it would just be me and this hyper girl that night. Oh, well, you have to start some-

where, I thought. Suddenly, the door burst open and 10 other girls stepped inside. Taking a seat on the floor, they began chattering noisily about their classes that day.

"Hey, everyone," Becky interrupted. The room hushed. "This is Vickie. She's going to be our Bible study leader."

All eyes locked on me. Okay, this was it — the moment of truth. Either they would like me or they wouldn't. I told them how happy I was to be there and then eased my way into that night's Bible lesson. Women living in scholarship halls like to learn. These girls treated each Bible study much like they would one of their university classes. They asked questions and pondered answers. They discussed among themselves. As the study progressed, I became energized and challenged. I had to be certain of what I taught to stay one step ahead of these smart, young women.

As the weeks went by, the study grew, until nearly half the hall was attending. Some girls showed special sensitivity to the Bible lessons. I invited each of these to study more in depth with me, particularly lessons centering around salvation. A few accepted, including Becky.

Ever since that first day when she rappelled without ropes down the scholarship hall stairway, I believed God had his eye on Becky. She had energy, charm and charisma and immediately drew others to her. I knew God had a plan for her and loved her. It didn't take long before I loved her, too.

I will always remember the day I taught Becky the gospel message that Jesus died for her sins and wanted her to accept his sacrifice.

"Why didn't anyone tell me this before?" she asked, tears streaming down her face as she sat at my kitchen table.

"It doesn't matter what happened before," I told her. "What does matter is that you accept Jesus into your life and make the decision to live for him from here on out. Will you do that?"

Becky readily agreed and sped back to the hall to tell her friends the good news. That night they all attended her baptism. Becky stood before our Bible study group and told the other girls about her decision. She articulately explained how she was tired of her sins and was eager to be forgiven. Her actions and her words spoke volumes as she witnessed to her hallmates. Several others followed her lead and also became Christians.

That school year, I observed a close fellowship forming with these young women. They challenged each other to stay on track and continue learning. They supported each other during tough times. They confessed sins and weaknesses and asked many questions about appropriateness in their dating relationships. They worshiped and prayed together. And they stayed connected to my family, babysitting for my children and serving me in many ways. I was very proud of them all. In fact, I

still am. Today these women remain faithful to God. They all have married and many of them have children of their own.

On May 4, 1989, a caravan of scholarship hall women made their way to my house. The semester was ending and they were going home for the summer. Filing into my living room one-by-one they waited for someone to start their presentation. I wasn't surprised that it was Becky who rose to speak and present me with a gift. I still study from the leather-bound Bible they pooled their money to buy. And I still open it each day and read the verse they printed alongside their signatures inside the front cover:

"How can we thank God enough for you in return for all the joy we have in the presence of our God because of you?" I Thessalonians 3:9

Almost a decade later, I often ask the same question.

Did you ever wonder why you were born? Why are you here and what are you supposed to contribute to society? What is the purpose of your life? Even as a child, I pondered such questions. I wondered why I was born surrounded by Kansas wheat fields and not in a tiny African village or amidst the green of Ireland. Why was I born in 1956 and not 1156 or even 2156? Was my birth a cosmic accident, or is there some master plan that includes my life?

Before I knew God, very little made sense. Since discovering His love and His Word, I have a greater understanding about the mysteries of life. We'll never know everything, but biblical passages like Acts 17:24-28 help lift the fog.

The God who made the world and everything in it is the Lord of heaven and earth and does not live in temples built by hands. And he is not served by human hands, as if he needed anything, because he himself gives all men life and breath and everything else. From one man he made every nation of men, that they should inhabit the whole earth; and he determined the times set for them and the exact places where they should live. God did this so that men would seek him and perhaps reach out for him and find him, though he is not far from each one of us. "For

in him we live and move and have our being." As some of your own poets have said, "We are his offspring."

These verses indicate that God created the world and everything in it, including people. He had a plan from the very beginning that included each one of us. In His wisdom, He decided when each person should live and where they should be born. Like a divine architect, God dreamed each of us, drew up the plans, uniquely molded and crafted us, and determined the best time for us to inhabit the earth. The reason: Because He loves us, He made it as easy as possible for each of us to find Him.

God knows there are many distractions in earthly life. If He had determined me to be a pioneer woman, I would have spent much time at the scrub board, plowing behind a mule, and whining about my tough existence. I envision little time to seek His face, because by nature, I need time for reflection. As long as there is work to be done, I forget to contemplate spiritual matters. God knew I would seek Him more diligently and listen to his voice more clearly if I wasn't constantly engrossed with physical tasks. He allowed me to be born in this era of washing machines, automobiles and a multitude of time-saving, small appliances.

God could have programmed us to believe in Him from our conception. However, He doesn't want to be served by human robots. He wants us to love Him and desire time with Him. He gives us free will, a chance to make our own choices. But He desires a relationship with us. By carefully choosing the time and place for you to live, God increased the odds that you will seek Him. Think of it this way: No mother wants her children to obey her because they are forced to do so. She wants their obedience because they love her and want to please her. It's the same with God. He doesn't coerce anyone into obeying

Him or even into spending time with Him. Instead, He hopes we will grow to love Him, which will result in obedience.

Women have always had a special place in God's plan. When God saw that man (Adam) was lonely, He crafted woman. He could have fashioned a television set, complete with remote control, or a sports car or even another man to be Adam's companion. He could have created Adam asexual, filling the earth entirely with men. But God knew that woman would complete man, that she would be significant to him. Women bring a sensitivity to the male perspective. They often see things men overlook and accomplish tasks men don't even realize exist. Women and men complement each other, bringing balance to humankind.

From Genesis on through the pages of the Bible, women had an active role in God's designated plan. Women were last at the cross when Christ was crucified (Mark 15:47). They were first at the tomb when he rose from the dead (John 20:1). They were first to proclaim the resurrection (Matt. 29:2). They were the first witnesses to the Jews (Luke 2:37-38). They attended the first recorded prayer meeting (Acts 1:14). They were first to greet the missionaries (Acts. 16:13). And the first European convert was a woman (Acts 16:14). There is no denying that God loves women.

Women have likewise been important in ministry to God and to His people. Romans chapter 16 lists those whom Paul credits with active ministries. There are 29 people mentioned in the first 16 verses. At least ten are women. Paul described Phoebe as a servant of the church and a great help to many people, including himself. He called Priscilla a fellow worker in Christ Jesus and said she risked her life for him. (Priscilla traveled with Paul and also took people into her home so she, along with her husband,

Aquila, could teach them about Jesus. [Acts 18:18, 24-26])
Paul wrote that Mary, Tryphena, Tryphosa and Persis
worked very hard for the believers. Junia, an older
Christian, had been in prison with Paul. Julia and the sister
of Nereus were both worthy of Paul's special greeting.
And Rufus's mother had treated Paul like a son. Paul
could not have accomplished as much for the Lord had it
not been for the encouragement and support of women.

The women in the Bible pursued God's ministry dur-
ing their time. This is our time. God chose you to be
born in this era because He wants you involved in His
ministry now. "For we are God's workmanship, created in
Christ Jesus to do good works, which God prepared in
advance for us to do" (Eph. 2:10). Even before you were
born, God gave thought to how He could use your gifts
and talents to serve those around you. The verses just
before this one make it clear that our works have nothing
to do with our salvation. Salvation is a free gift; you can't
earn it. We don't work to be saved. We work for God
because we are saved.

If you are a Christian, you have volunteered to be an
ambassador for Christ. "We are therefore Christ's ambas-
sadors, as though God were making his appeal through
us" (2 Cor. 5:20). You might be the first taste of God
some people get, the first Bible some people read, the first
glimpse they see of Jesus. An ambassador is a representa-
tive. Since the president of a country cannot be at numer-
ous places at the same time, he sends ambassadors to
speak on his behalf. What a privilege to know God choos-
es us to be ambassadors for Him! He could have allowed
mountains to shout his praises. He could have told flow-
ers and plants to witness to passersby. He could have
made birds and animals serve the church. Instead, he
chose us — you and me.

If being an ambassador for Christ is so wonderful, why don't we do it more joyfully, more eagerly? What keeps us from telling others about God's mercy? We have been given eternal salvation and a message of redemption. Why, then, do we hesitate to share such great gifts? What holds us back from spreading God's Word and His love to everyone we know?

There are hindrances to ministry. It takes time and energy to serve and to witness. Self-control and determination are necessary to stay on the front lines in spiritual battle. People are self-centered by nature. Too often, we are consumed with what we want to do, how we want to spend our time, and ways to have more fun. Being an ambassador takes determination. We must keep constant communication going with the One we represent. Each day we must ask ourselves, "Am I going to live for God today, or myself?" Salvation is a one-time decision. Ministry is an every day resolution.

When God gives you a specific task to accomplish, what is your attitude? "Not today, God, I'm really busy." "Why don't you ask someone else? I don't think I want to do that." "You want me to do *what*?!?" When God called Samuel and Abraham, each had the same response: "Here I am, Lord." In Isaiah, chapter 6, God revealed himself to Isaiah in a powerful vision. God needed His message carried out to the people. "Whom shall I send? And who will go for us?" He asked.

Isaiah replied, "Here am I. Send me!" Isaiah's response is the one God desires from us as well. When He calls you to meet a new neighbor or to care for the children of a sick friend, your response needs to be, "Here am I. Send me." When he gives you the opportunity to share your faith or teach a Bible study, answer Him with, "Here am I. Send me." When He asks that you stand alone on His

principles when others around you don't seem to care, take heart and say, "Here am I. Send me."

I once found myself involved in a project I did not desire. The pursuit was godly, but the road seemed awfully bumpy and very unpopular. Our school system was piloting a self-esteem program in my daughter's junior high school. It was presented to parents as a drug and alcohol prevention program, but one look at the curriculum revealed a definite values clarification scheme. I knew enough from researching the subject of values clarification that this method would not have positive results on children. Values clarification is a method developed in the 1960's for use with mentally ill adults. It was not intended to be used on healthy, developing adolescents. Plain and simple, it is psychological manipulation.

It became evident that God was calling me to take a stand in this battle. New pieces of information arrived at my door almost daily. Strangers from across the country called me out of the blue. I was introduced to others in my community who had the same concerns but did not know what to do. We assembled at the town library, each bringing a few friends. We copied and distributed materials downtown, alerting others to the potential problems this program would cause if adopted by our schools. I spent months collecting and sorting information, speaking about my findings, writing and rewriting fact sheets for distribution, and talking to administrators about my concerns.

Many times I grew weary. I often wondered if I was accomplishing anything or merely wasting my time. Overwhelmed by the project, I prayed for other workers. "Please, God, give this to someone else to do. I am tired," I begged. I could have chucked the entire project in the trash can and walked away. But I felt a constant leading by God not to abandon ship. I was prodded to

stay the course. So, sometimes half-heartedly, I trudged on until my family went on our summer vacation.

I was scheduled to address the school board with my concerns the day we returned from our trip. But while we were away, a fellow worker lined up an instructor of education from our local university and an educational psychologist. Both would speak at the school board meeting concerning the negative consequences of the pilot program. When I got back from vacation, there was a note taped to my door from Nancy, my fellow ambassador. "Welcome home and congratulations! The school board decided to drop the matter. Too controversial."

It is unbelievable what God can do through us if we don't give up. Our minds and imaginations are very limited. We only see what is happening at the time. God sees the big picture. He knows the outcome before it happens. All He asks of us is to stand firm and faithfully march on one step at a time.

Ungratefulness can prevent a ministry from reaching fulfillment. New Christians are some of the most enthusiastic people to be around. Being newly forgiven brings a joy never before experienced, and recent converts are anxious to tell anyone and everyone what Jesus has done for them. Unfortunately, over the months and years, that enthusiasm dwindles for most people. The Christian life becomes comfortable. When we become numb to the sacrifice Jesus made on our behalf, we grow casual about sharing the message. Oh, we might continue to teach a Sunday School class if asked. But personal evangelism diminishes if we forget the life from which we were rescued.

As for you, you were dead in your transgressions and sins, in which you used to live when you followed the ways of this world and the ruler of the kingdom of the air, the spirit who is now at work in those who are disobedient.

All of us also lived among them at one time, gratifying the cravings of our sinful nature and following its desires and thoughts. Like the rest, we were by nature objects of wrath (Eph. 2:1-3).

Spiritually, we were dead before conversion. Unable to save ourselves, we were driven from one sinful act or thought to another. In a word, we were despicable.

"But because of his great love for us, God, who is rich in mercy, made us alive with Christ even when we were dead in transgressions — it is by grace you have been saved" (Eph. 2:4-5). Christians should be the most joyful people on the planet. When we make the decision to let Christ rule our lives, we are reborn in God's love. We have purpose and salvation and have been granted mercy, or pardon, by God. That is cause for celebration. Those with a full understanding of being transformed from a hopeless sinner to a heaven-bound saint can't help but share how God graciously wiped their slate clean for a second chance.

Fear can stall out a ministry. Most people worry too much what others think of them. "She might think I'm some sort of religious fanatic if I tell her about Jesus." "I can't invite my boss to church. He might fire me." "What will my friends say if they find out I go to church every Sunday?" "She will hate me if I point out her sin." If Paul had worried about what others thought, the gospel would not have advanced throughout the world. Paul had every reason to be fearful. There were people in his day who did not take kindly to Christians. Paul was beaten, stoned and imprisoned for being an ambassador for Christ. While some Christians around the world still face persecution today, most of us can freely witness without fear or retribution.

Someday the saints in heaven will swap stories about their time on earth. The subject of persecution will undoubtedly surface for discussion.

"I was stoned three times. That third time finally got me. That's how I ended up here," a first century Christian will admit.

"I was sawed in half for the sake of the gospel," another soul will add.

"The rulers of the land threw me in a pit with a bear. I was mauled to death because I wouldn't stop speaking about Jesus," a third will contribute.

Turning to a 20th century Christian, someone will ask, "And what terrible torment did you endure for the cause of the cross?"

"Oh, well . . . I, uh . . . someone once made fun of me. Does that count?"

Fear is not from God. God, being perfect love, casts out fear (1 John 4:18). Christians must willingly meet the challenges and discouragements that Jesus promised will come. Some will threaten your ministry. But the One you follow understands. He endured many hardships to save your soul. He asks you not to be afraid.

> Do not be afraid of those who kill the body but cannot kill the soul. Rather, be afraid of the One who can destroy both soul and body in hell. Are not two sparrows sold for a penny? Yet not one of them will fall to the ground apart from the will of your Father. And even the very hairs of your head are all numbered. So don't be afraid; you are worth more than many sparrows (Matt. 10:28-31).

In addition to self-centeredness, ungratefulness and fear, the pain of life can also get in the way of mission. Maybe you suffer physical pain or sickness. It could be that pain from an abusive childhood constantly resurfaces. For some women, emotional pain is caused by a straying husband, a rebellious child, loss of income, or a loved one's suicide. As long as you live on earth, you will inevitably face pain. The challenge is to keep pain from shackling you or worse yet, destroying you.

Great ministries come from pain. God can use wounded souls. A young woman who has experienced a miscarriage is best suited to comfort another experiencing the same loss. A woman whose mother is in a nursing home can best advise another woman about to walk the same path. The woman whose husband left her for someone else is best equipped to help another woman weather a similar storm. A woman in remission from cancer can best serve another just beginning the process and pain of chemotherapy.

Pain is seldom worthless. We learn something about ourselves and our God through suffering. God allows us to face painful circumstances so we will be equipped to minister to others who also walk the rocky road of life.

> Praise be to the God and Father of our Lord Jesus Christ, the Father of compassion and the God of all comfort, who comforts us in all our troubles, so that we can comfort those in any trouble with the comfort we ourselves have received from God. For just as the sufferings of Christ flow over into our lives, so also through Christ our comfort overflows (2 Cor. 1:3-5).

Pain produces strength, refines character and reveals purpose. We mature through hardship. During the 1996 Summer Olympics, two American athletes epitomized perseverance through pain. They refused to let suffering become an obstacle to their goals. Jair Lynch became the first black American to medal in men's gymnastics. Before winning his silver medal, Lynch thought about forgoing the parallel bars. He had split open a dime-sized callous on his left hand during warm-ups. Calling himself a "bloody mess," he sliced off the dead skin, applied pressure and ointment and decided to proceed with his event. Soaring high above the parallel bars and nailing his landing, Lynch knew he had made the right choice by pushing past pain.

"It really helped me focus on gymnastics and took away any possible distractions," the gymnast later told a reporter concerning his painful hand. Lynch's pain paved the way to a medal. Had he been pain-free, he wouldn't have concentrated as hard on his event. With each turn on the parallel bars, the burning pain reminded this young man about the heights he wished to attain.

America also watched as tiny gymnast Kerri Strug fought past pain to claim a gold medal for her team. During an awkward vault landing, Strug tore the ligaments in her ankle and could barely walk. Yet, in an heroic effort, she managed to rise above physical pain long enough to complete a final perfect vault. Strug's pain was so intense that she had to be carried onto the winner's platform to receive her gold medal.

There are spiritual lessons to be learned from these courageous Olympic athletes, whose pain threatened to steal their dreams. Our goal is to be productive for God. We can't prevent pain from cropping up in our lives, but we must learn to cope with it, rise above it or eliminate it. It is okay to seek outside, professional help in dealing with long-term pain. If emotional pain is holding you back, a Christian counselor can help. Some women hesitate to seek psychological help. If you had cancer, what would you do? Probably seek out a doctor, have surgery or treatments — whatever was necessary to restore your health. The same should apply to emotional health. You are not a weakling, and there is no shame in admitting you need help and getting it.

Ministry involves risk-taking. One of the greatest stories about a woman in the Bible is that of Esther. Esther was a Jewish orphan, raised by a cousin, Mordecai. Being very beautiful, Esther was brought as a candidate for the king's new wife. She won King Xerxes' approval and

became queen, keeping her nationality secret from her husband. Because of a plan of Haman, an evil servant, all the Jews were to be destroyed. Mordecai asked Esther to save her people, saying the Jews were in great distress because of the king's edict of destruction. "In every province to which the edict and order of the king came, there was great mourning among the Jews, with fasting, weeping and wailing. Many lay in sackcloth and ashes" (Esther 4:3).

Esther sent word to Mordecai explaining that anyone approaching the king with a request who had not been summoned by him would be put to death. The only exception to the king's law was if he extended his gold scepter to the requester, sparing her life.

"Do not think that because you are in the king's house you alone of all the Jews will escape," was Mordecai's reply. "For if you remain silent at this time, relief and deliverance for the Jews will arise from another place, but you and your father's family will perish. And who knows but that you have come to royal position for such a time as this?" (Esth. 4:12-14).

Esther responded back with courage, compassion and sensitivity for her people. She decided her life was worth risking for the sake of the Jews and turned the matter over to God.

"Go gather together all the Jews who are in Susa, and fast for me. Do not eat or drink for three days, night or day. I and my maids will fast as you do. When this is done, I will go to the king, even though it is against the law. And if I perish, I perish," was Esther's determined and brave answer (Esth. 4:15-16).

God was with Esther. The king listened to her, Haman's scheme was foiled and the Jews were spared. Had Esther not been willing to take a risk, had she been concerned

only with her new life inside the king's palace, thousands of people would have been slaughtered.

You, too, have been born for such a time as this. There is much work to be done in the kingdom of God. Look for ways to serve God and His people. We won't all have the same ministry, since each of us have different gifts and talents. Some will minister in prisons. Others will witness to the lost or attend to the sick. Some will become prayer warriors. Others will teach children. A few will counsel. Be creative; ministry should be fun and energizing. Every ministry is worth pursuing because God has called you to it and He will help you accomplish it. If you don't know what your specific ministry should be, ask God. He will be glad to find a job designed especially for you.

Jesus said, "I tell you, open your eyes and look at the fields! They are ripe for harvest" (John 4:35). Recognize harvest time. Roll up your sleeves and get to work. Harvesting brings great joy and reward. Sure, ministry can get tiresome. It also presents a few challenges and struggles along the way, but nothing worthwhile ever comes easy. When you get overwhelmed in ministry or feel like crying because of your own pain or that of another, remember this verse, "Those who sow in tears will reap with songs of joy. He who goes out weeping, carrying seed to sow, will return with songs of joy, carrying sheaves with him" (Ps. 126:5-6).

I will be eternally grateful for Brenda, the woman who willingly shared God's love and forgiveness with me. After I became a Christian, Brenda confessed that she went home and cried after each Bible study session with me because I was suspicious of her motives and skeptical of God. Brenda sowed my salvation with many tears. She helped me pluck the weeds of sin from the crop of my life.

And when I finally turned my face toward the cross, she reaped the results of her ministry with songs of joy. I'm glad she saw the harvest through to the end.

Reflecting on My Face as God's Ambassador

2 Corinthians 5:14-21

What is the motivation for ministry?

In what ways do you still live for yourself?

How can you overcome that and choose each day to live for God?

How are we to see others (vs. 16)?

What is the ministry of reconciliation?

Are you a good ambassador? How could you improve?

2 Corinthians 6:1-2

Do you take God's grace for granted?

How can you use this time to pass salvation on to others?

2 Corinthians 6:3-10

What pains got in the way of Paul's ministry?

What do you think was the key to his perseverance?

What is your greatest pain in life?

What would be necessary for you to turn this pain into triumph?

2 Corinthians 1:6-7; 9-11

What experience do you have to use in comforting others?

Does your personal pain cause you to rely on God? How?

What role does prayer play in pain and ministry?

Matthew 10:32-36

Is it easy for you to acknowledge Jesus before others?

Will ministry always be easy?

What personal hardships have you encountered by sharing your faith?

Romans 8:31-39

Whose side is God on? How do you know?

What trouble threatens to separate you from God?

How can you keep that from happening?

Memorize Isaiah 7:9b.

Facing
the Sunset
⟨✦12✦⟩

Rosetta was an elderly, Christian woman without material wealth and with more than her share of health woes. Arthritis crippled her hands and hips and prevented her from straightening her back upright. Her diet was severely limited by progressively worsening diabetes. Chest pains tired her during the day and leg cramps came in painful waves each night. But determined to remain productive until the end of her days, the 90-year-old widow greeted each day with a smile and a prayer.

Whenever a new baby was born in her congregation, Rosetta, despite her disfigured fingers, crocheted a baby-sized afghan. Her homemade cinnamon rolls, bread and pies were a favorite at church potluck dinners. Rosetta's entire backyard was a garden. She raised potatoes, tomatoes, squash, green beans, onions and a host of colorful flowers. She made sure her church building was frequently dressed in peonies, roses and zinnias. Every Saturday morning for many years, Rosetta rose before the sun to bake bread and pick flowers. Piling her wares into her dilapidated Chevy, she headed for the farmer's market. Although, she could have used the money herself, Rosetta deposited her meager earnings into a bank account and gave control of it to the elders at her congregation. They were asked to allocate these funds to the needy.

Each day was a physical struggle for Rosetta. But God, her Bible and the church gave her strength. And then one cold winter, Rosetta's physical infirmities won the battle. A terrible cold turned into pneumonia and her spine deteriorated to the point of immobility. The pain in her lungs, coupled with the pain in her back, was excruciating. No longer able to care for herself, Rosetta regretfully entered a nearby nursing home.

Most people would struggle to find joy in being bedridden and partially paralyzed. Rosetta was no ordinary woman. With a trust deeply rooted in God, Rosetta, confined to her bed, prayed daily for God to give her a ministry in the nursing home. She missed witnessing to her neighbors and customers at the farmer's market. She longed to sing with her congregation and visit with her spiritual brothers and sisters. Her desire to make a difference in the lives of others didn't end when her body gave out.

God can use anyone with a heart for service, even those with less than perfect health. He heard Rosetta's prayers and gave her the idea to distribute Bibles to those who entered her nursing home room. She called her minister and asked him to visit a local outlet bookstore.

"I want you to buy a case of Bibles and bring them to me," she instructed.

Rosetta kept her box of Bibles within arms reach of her bedside. And true to the promise she made to God, she offered them to those who came to care for or visit her. One day, a new housekeeper entered Rosetta's room and began sweeping under the bed. Rosetta heard the woman complaining under her breath and watched her furious broom strokes on the linoleum tile floor. But she didn't let the cleaning woman's foul mood spoil her ministry attempts.

"Do you have any children?" Rosetta blurted out to the obviously angry woman. The sweeping stopped.

"Yeah, I got kids — seven of 'em. Wanna guess who's raising 'em? Me! That's who. Never got one red cent from their so-called father."

"Do you ever take your children to church?" Rosetta persisted.

"No. Don't got no time. Gotta work on Sundays."

"Would you be offended if I gave you a Bible?" Rosetta quickly plucked a Bible from the box and held it out to the cleaning woman. "You see, my mother used to read the Bible to us kids every day. We loved to gather around while she read these great Bible stories to us. So if I gave you a Bible, you could read it to your kids."

Tears welled up in the woman's tired eyes. At that moment, she realized Rosetta, crippled and bed-ridden, understood pain and suffering. She could also see that this tiny, elderly lady had a peace in her life that only God could provide. The woman longed for that herself. With a smile of gratitude, she reached out and took the Bible. Then ever so gently, she bent down over the bed and hugged Rosetta.

Rosetta never saw that woman again. For reasons she never learned, the cleaning lady only worked that one day at the nursing home. God had brought her to Rosetta's room to put a Bible into her hands and encourage her to teach her children about Him. We do not decide when our days on earth are over. And even when our bodies and our strength give out, God still allows us to serve with soul and spirit. Rosetta has gone on now to be with her Father in heaven where she can run and not

grow weary, where she soars on wings of eagles. And hopefully one of these days, she will again see that housekeeper, with seven eager children following close behind.

Each of us was born into this world with a brilliant sunrise unfolding in the background. At that moment, a new day dawned. Glorious orange and golden rays illuminated the joyful occasion and shot across the sky with promise for the future. We journey through many seasons in the sun throughout the course of life. Some are warm and comforting. Others scorch and threaten to wither the traveler. Then when every season allotted has been weathered, the sun quietly slips off its throne and slowly descends from the sky. Quicker than expected, the sinking sun settles on the horizon. Spectacular pink and purple fingers reach from the sunset and beckon us home, where the Son lovingly shines forever.

Women begin to first notice the setting sun when midlife approaches. Somewhere between ages 40 and 50, we begin realizing we must face the sunset. I begged my husband not to throw an over-the-hill bash when I turned 40. A few months prior to my birthday, I attended such a party when a friend turned the Big 4-0. I empathized with Diane as she obligingly opened her gifts and tried to laugh at the fake false teeth, the can of prune juice, and the cane equipped with a rear-view mirror, while black balloons loomed overhead like a pack of hungry vultures. I couldn't even bring myself to eat a piece of the tombstone-shaped cake, realizing I would reach the middle-aged milestone next. That night was the first time I associated a birthday with actual aging and eventual demise. No party for me, thank you.

So, when I turned 40, I skipped town. I went back to the place I was born and had spent my childhood. I took a driving tour of all the houses I had lived in, the schools I had attended, and the homes of all my relatives in the area.

I even visited the day care center, where I was placed following my parents' divorce. I also called on a couple of classmates from high school. With each stop, emotional memories flooded my mind. This trip was my midlife gift to myself and proved much more meaningful than an over-the-hill party. I needed to know where I had come from to see clearly the path where I would venture next. Although at times painful, my trip down memory lane provided an avenue of healing and a discovery about midlife.

"Midlife crisis" has become a common term in modern society. The first 40 years or so are spent building a future and achieving a certain level of stability. Then somewhere around the fortieth birthday, the realization of unattained accomplishments and unreached heights comes into view. Midlife becomes a time of loss — lost dreams, unachieved goals, fading youth, diminishing energy, departing children and dying parents. Women also face lost fertility during this time. We try to prepare ourselves for each of these losses. We read books on the empty nest and menopause and think we'll be ready when the time arrives. However, until the loss is right there staring us in the face, all the books in the world can't help brace us.

Shortly after I turned 40, my youngest child began modeling. As I fought hard to keep the lines on my face from spreading any further and the newly sprouted white hairs well blended with the blonde ones, magazine representatives and New York City agents began calling Lydia. Shopping with her turned depressing. Everything she tried on her 5'9" frame looked fantastic, while I diligently avoided anything that would reveal sagging skin and body parts that had somehow drifted overnight. Struggling to avoid looking it, I instantly felt old, ancient, quite fossil-like. My soul believed it was still 18, but my body said, "Forget it, sister. You're long past that!"

Women, especially those in this country, are constantly faced with a standard of beauty. Perfect faces smile at us from the magazine rack in the grocery aisle. Commercials remind us to buy the host of products supposedly necessary to maintain our looks. Growing up our mothers told us that pretty is as pretty does, but society says it's a lot more complex than that. So we struggle to hang on to our youthful appearance as long as we can. Eventually though, the hair dying and the face cream slathering come to a halt. It's then that we realize beauty is in the eye of the beholder, and to God, we women are all beautiful. Before you buy that next jar of miracle, antiaging cream, read 1 Samuel 16:7b: "The LORD does not look at the things man looks at. Man looks at the outward appearance, but the LORD looks at the heart." God designed your packaging, but He is more concerned with the condition of your soul.

First Peter 3:3-4 is often misconstrued. Speaking about women: "Your beauty should not come from outward adornment, such as braided hair and the wearing of gold jewelry and fine clothes. Instead, it should be that of your inner self, the unfading beauty of a gentle and quiet spirit, which is of great worth in God's sight." This verse is sometimes used to discourage women from wearing jewelry or certain clothing and hairstyles, but what this Scripture really says is that a woman's spirit should outshine her appearance. A woman can be absolutely, drop-dead gorgeous on the outside, but selfish and hateful in attitude. A positive, giving spirit is what will attract others. Outer beauty fades over the years, no matter how many braids or pieces of expensive jewelry accompany it. Inner beauty lasts a lifetime.

Be glad you don't live in Old Testament times when fertility was a public issue. In Leviticus, Jewish women

were commanded to follow certain sanitary rules centering around their monthly cycle. In those days, everyone in the camp knew when a woman was having her period, when she was pregnant or post-partum, and when her childbearing days were over. Thankfully, today, women can keep things a little more private. Even though there are now drugs that can extend our fertility, menopause is still an emotional time of life. No longer being able to bear children is a considerable loss for many women. In their minds, it signals the end of youth.

Youth, like beauty, is more subjective than we might think. I know many older people who have very youthful attitudes. Zoe and her husband, Cliff, are two of them. I was assigned to interview Zoe and Cliff when they celebrated their 70th wedding anniversary. I expected to find two very decrepit, 90-year-olds and wondered how much they could still hear, see or understand. To my surprise, I found this couple to be quite spry and youthful. During the interview, Zoe and Cliff sat side-by-side on their couch, holding hands. They frequently smiled at each other and called one another by endearing, little pet names. Even after 70 years together, it was apparent these two were still very much in love. Either someone forgot to tell them they were old or Cliff and Zoe knew the secret of Proverbs 5:18-19. "May your fountain be blessed, and may you rejoice in the wife of your youth. A loving doe, a graceful deer — may her breasts satisfy you always, may you ever be captivated by her love." A youthful spirit does not have to age along with the body when you learn the secret of love and contentment.

Children grow up and leave. Parents age and die. Beauty fades and energy wanes. Fertility depletes. Dreams go unfulfilled. How can we ever cope with the losses that accompany midlife? First, we need proper perspective. If

you consider that all you have came about because of your efforts, then loss will devastate you. However, you can't lose what you don't own. If you believe that all you have is on loan from God — that everything really belongs to Him — then you can't lose anything. You simply give things back to their rightful owner when He asks. No one wants to lose things, but we don't mind giving them up for a purpose or after their usefulness is completed.

Giving brings joy. Parents establish wills so that after death, their children will receive meaningful tokens from their parents' lives. In Genesis, Isaac prepared on his deathbed to give his son Esau a blessing, an oral will of sorts. The blessing was important because not only did it establish ownership of tangible property and possessions, it also passed on a legacy and a prophetic vision for the future. Men like Isaac didn't lose their heritage; they willingly passed it on to the next generation.

Maybe you feel like midlife signals the beginning of a downward spiral loss cycle. But maybe it's simply a time to take stock and count what is most valued. Solomon reminds us in Ecclesiates that we come into this world with nothing and we depart the same way. Accepting this principle, midlife could usher in a time to count our blessings, consider our relationships and make sure we are right with God. The Apostle Paul's attitude on this subject is worth pursuing: "[W]hatever was to my profit I now consider loss for the sake of Christ. What is more, I consider everything a loss compared to the surpassing greatness of knowing Christ Jesus my Lord, for whose sake I have lost all things. I consider them rubbish, that I may gain Christ . . ." (Phil. 3:7-8). You see, it's all a matter of perspective.

There are benefits to aging. Instead of focusing on apparent loss, look at what is gained by growing older. Job

12:12 reminds, "Is not wisdom found among the aged? Does not long life bring understanding?" I know so much more now in my forties than I did in my twenties or thirties. I look forward to having even greater understanding and increased wisdom in the years ahead. Understanding and wisdom come about through experiencing life. Each triumph and each hard knock teaches us a lesson. The longer you live, the more lessons you learn. The more lessons, the greater the understanding. Every older person's life reads like an interesting novel and an intellectual textbook, and all the chapters disclose valuable lessons.

Another advantage to aging is time. Young people are constantly chasing this direction or that, pursuing an education, earning a living, raising a family. They seldom have time to pursue personal endeavors such as travel, hobbies, or even relationships. Older people have the blessing of time. After retirement, my grandparents traveled to Arizona each winter where they made many friends, attended flea markets and scouted nature adventures. Some of their happiest memories were built during those years.

Older folks also have more time for spiritual pursuits. When Jesus was born, there was a prophetess named Anna who used her time for praying and worshiping. "She was very old; she had lived with her husband seven years after her marriage, and then was a widow until she was eighty-four. She never left the temple but worshiped night and day, fasting and praying" (Luke 2:36-37). Advancing age allows time to know God, serve the church, share your faith, pass on a biblical heritage to grandchildren and pray for all those younger folks who are running around in a frenzy.

Psalm 139:16 tells us that our days on earth are numbered. The reality is we all must die. "What man can live and not see death, or save himself from the power of the

grave?" (Ps. 89:48). Some will die young. Many will grow old first, but eventually they will still die. Only God knows which is in store for you. Ever since Adam and Eve disobeyed and ate from the tree of the knowledge of good and evil, the curse of physical death has been upon mankind. The thought of death scares me — not the end result, but the actual death process. Let's face it — there aren't many pleasant ways to die. I would like to be like Enoch who, without pain and suffering, "walked with God; then he was no more, because God took him away" (Gen. 5:24). But I don't count on that happening.

When we know that death is inevitable, we give more thought to life. To get the most out of life, live as if each day were your last. How would you spend today if you knew you would die tomorrow? Bet you wouldn't be reading this book! You would call everyone you cherish and tell them you love them. You would skip cleaning the house to share special moments with your husband and children. You would talk to God and ask Him for smooth passage. You would allocate your most treasured possessions. You would go outside and enjoy one last sunset. You wouldn't waste time watching television, gossiping about the neighbors, fretting over your schedule, or shopping for status symbols. Each minute would count. Each person would be important. Each word spoken would hold value.

Not long ago, a beautiful soul passed from this world. Knowing she was dying from pancreatic cancer, Sarah called each of her three daughters and nine grandchildren separately into her bedroom. Alone with each one, Sarah disclosed what she valued most about each person and what she hoped for his or her future. She did the same for many of her close believing friends. Those friends and relatives she treasured, but who had not come to know the

Lord, Sarah encouraged to earnestly seek Him before it was too late. Using what little time she had left, this wonderful woman of faith blessed her family with tender words, challenged her Christian friends to continue walking their God-directed paths, and witnessed to those who still needed to make peace with God.

God understands death. Jesus was dead for three days following his crucifixion. God could have raised him up immediately, but He didn't. He allowed three days to pass so we could believe that Jesus fully understood every obstacle we face in life — even death and the dying process. Jesus dreaded the pain of his impending death. Realizing his physical demise was very near, he retreated to the Garden of Gethsemene to pray for strength. He knew the torturous death he would soon face and feared the physical suffering.

> He withdrew about a stone's throw beyond them, knelt down and prayed, "Father, if you are willing, take this cup from me; yet not my will, but yours be done." An angel from heaven appeared to him and strengthened him. And being in anguish, he prayed more earnestly, and his sweat was like drops of blood falling to the ground (Luke 22:41-44).

If you fear dying, take heart knowing Jesus didn't relish the idea either. His massive drops of sweat proved the point. Jesus already knew the wonders of heaven. He had been there before and looked forward to returning. It wasn't death that frightened him, only the process of getting there.

God knows death is our enemy. "The last enemy to be destroyed is death" (1 Cor. 15:26). God's plan to destroy death is through His Son, Jesus. For the believer, the cross defeated the finality of death. If you have put your trust in God, you will still endure a physical dying process,

but your soul will never die. It will only move on to a heavenly adventure.

The dying process is parallel to the birth process. The womb is a cozy place for a baby. Inside her mother's body, the baby is warm, well-fed, safe and protected. When things get a little too cramped in there, it's time for the birthing process to begin. But why would the baby want to leave such a warm and wonderful world to venture into the unknown? Because there are two people on the other side of that womb saying, "Come on out. We can't wait to see you, to hold you in our arms, to take care of you, to love you." To greet her eagerly awaiting parents, the baby must give up the secure, familiar womb to be uncomfortably squeezed, with each of her mother's contractions, finally reaching love on the other side.

Birth typifies the dying process. When our time nears, we might want to say, "No, God, I'm not ready. I kind of like it here on earth. I've got things to do yet. Don't take me now. I'm comfortable here and I don't want to say good-bye to my family this soon. Please, just a little longer."

To which God replies, "No, daughter, I've waited long enough. I want to hold you in my arms, to take care of you forever and ever. Come on over and let me show you real love." And as the dying process squeezes the breath from our bodies, we leave the familiar for a better, more loving existence.

We have to let go of this world to enter heaven. It's scary because all we know is what we have right here and now. Death and heaven are unknown, uncharted waters, and anything unknown is a little unsettling. But the Father waits with open arms and the promise of eternal joy and love. Dying is a necessary means to a new birth. From God's perspective, it will be a wonderful thing for

those who have believed in Him. "Precious in the sight of the LORD is the death of his saints" (Ps. 116:15).

When you face the sunset, don't fear. A sunset is a glorious example of God's artistic talent. The dying sun is every bit as beautiful, if not more, than a sunrise. Unlike the bursting energy of a sunrise, though, the sunset brings peace and tranquility. Remember, a sunset does not sharply drop from the face of the earth. It gradually, peacefully sinks below the horizon and quietly fades out of sight. Even then, we know the sun is still there and will rise again the next day. We, too, will fade from this world, only to rise again in the glorious splendor of another day. Only ours will be an eternal day that forever dawns with the love of our Father and the majesty of our Savior. We won't want to miss it.

God's Sunshine*

Never once since the world began,
Has the sun ever stopped shining;
His face very often we could not see,
And we grumbled at his inconstancy,
But the clouds were really to blame, not he,
For behind them he was shining.
And so behind life's darkest clouds
God's love is always shining;
We veil it at times with our faithless fears,
And darken our sight with our foolish tears,
But in time the atmosphere always clears,
For His love is always shining.

— John Oxenham

*John Oxenham, "God's Sunshine," *The World's Best Loved Poems*, James Gilchrist Lawson, compiler (New York: Harper and Row, 1927).

Reflecting on a Lifetime of Faces

Proverbs 31:30

How important is beauty?

What is more important?

Psalm 103:1-5

List the things outlined here that God has done for you.

How is youth renewed?

Luke 9:23-25

Honestly, how important are your material things to you?

What importance does God place on them?

In what ways could you begin to deny yourself?

What does that phrase mean to you?

How can you lose your life for Jesus?

Psalm 92:12-14

The righteous are being compared to trees in these verses. What qualities do they possess?

What fruit can the elderly bear?

How can you stay "fresh and green" — youthful?

Psalm 23

While she was in the nursing home, my great-grandmother had me read these words to her. Why do you think they comforted her?

Does the valley of the shadow of death scare you?

What do you think God wants you to know about it?

Rev. 14:13

Why are the dead blessed?

How are they rewarded?

If you died tomorrow, would you receive this blessing?

About the Author

Vickie Hull is first a Christian, then a wife, mother of three, newspaper editor and reporter, and a self-syndicated columnist. Her writings have appeared in *Christian Woman Magazine* and various newspapers. Hull has won numerous journalism awards, including being named a three-time first place winner for column writing in the Kansas Better Newspaper Contest. She earned top honors in feature writing as well. She was the Kansas weekly newspaper winner of the 1995 American Heart Association Health and Science Journalism Award. She also designs biblical curriculum for teenagers and women. Hull and her family live in Lawrence, Kansas.

Vickie Hull is available to speak at women's retreats, rallies, luncheons and conferences. To schedule an appearance, contact her at:

3009 W. 27th St., Lawrence, KS 66047,
or call (785) 865-4045.